NEW YORK CITY
·COFFEE·

NEW YORK CITY

·COFFEE·

A Caffeinated History

ERIN MEISTER

AMERICAN PALATE

Published by American Palate
A Division of The History Press
Charleston, SC
www.historypress.net

Copyright © 2017 by Erin Meister
All rights reserved

First published 2017

Manufactured in the United States

ISBN 9781467136006

Library of Congress Control Number: 2017934947

Notice: The information in this book is true and complete to the best of our knowledge. It is offered without guarantee on the part of the author or The History Press. The author and The History Press disclaim all liability in connection with the use of this book.

CONTENTS

ACKNOWLEDGEMENTS

Books don't write themselves, just like good coffee can't be brewed by total automation. There are many hands that touch the world's best beans before they become your delicious morning cup, and many personalities contributed to make this book a reality.

Thanks first and foremost to Stevie Edwards and Amanda Irle at Arcadia Publishing/The History Press, who saw value in the topic and gave me free rein to tell the story I felt needed telling. Gratitude as well to the rest of the editorial, design and marketing teams for their tireless work in making this thing tangible and readable. It's been an honor and a privilege.

Enormous thanks to the coffee men and coffee women who gave their time, energy, passion and trust to me by granting interviews, answering questions, responding to too-long e-mails, sending photos and generally being as generous as coffee people are known for being. Especial (and alphabetical) gratitude to Sarah Allen, Stephen Bauer, Abba Bayer, Caroline Bell, Andrew and Oren Bloostein, Amanda Byron, Dennis Crawford, Peter Giuliano; David, Karen and Sterling Gordon; Nicole and Steven Kobrick, Stefanie Kasselakis Kyles, Peter Longo, Caroline MacDougall, Kenneth Nye, Jonathan Rubinstein, Darleen Scherer, Karl Schmidt, Scott Tauber and Saul Zabar. Thanks as well to non–coffee professionals who pitched in with expertise and advice, including Donna Gabaccia, Jon Pace, Kim Racon, Oliver Strand and Jane Ziegelman. Big shout out, as well, to the New York Public Library and Hennepin County Library, without whose vast networks of resources this book would be nonexistent.

ACKNOWLEDGEMENTS

I owe particular gratitude to Donald Schoenholt, who is an absolute mensch, and who has gone above and beyond in helping, supporting, boosting, challenging and providing information for this project. I say in the book that he should probably have been its author, and I mean it. Instead, he went out of his way to assist me as I stumbled along trying to do a good job. I'm honored to have made such a seemingly unlikely friend, especially with someone as passionate about both coffee and Theodore Roosevelt as I am.

Appreciation must be shared for the folks who kept the day job fires burning while I focused on this. My work family at Café Imports has given me great freedom and support during this entire adventure, and I can't express enough love and admiration for my colleagues there. Massive thanks to Jason A. Long, Andrew P. Miller and Noah Namowicz for being inspiring leaders and trusting me to take on this project.

A huge hug to all the coffee professionals who have inspired, guided, forgiven and cheered for me along the way, both during this work and in my career. Coffee people are the best people.

Brett Leveridge gets a separate line of love and recognition, because he's the literal greatest.

Apologies to anyone I have unintentionally neglected; let's blame it on the caffeine.

INTRODUCTION

Attempting to write the history of coffee in New York is almost like attempting to write the history of the city itself. The people, places and processes that touch the caffeinated story of Gotham so thoroughly embody what the area represents—both to outsiders and insiders—that looking into the city's coffee cups has proved to be a microcosmic way of understanding what makes New York the unique and momentous metropolis it is. Coffee's history, like New York's, contains multitudes, many of which seem to contradict one another: ambition and luck, generosity and ruthlessness, success and failure, us and them.

One of the aspects that this regional history will emphasize is that while coffee is not technically a local product, there is more of New York in just about every cup of coffee and every bag of beans in the United States than most American consumers realize. If your coffee wasn't bought or sold here, it may very well have passed through the New York ports or warehouses; even if it didn't touch land or water in the greater Gotham area, perhaps it was traded on the commercial market that originated here, roasted using technology designed by a local or packaged in a bag or can whose design was dreamed up by the country's most innovative retailers—many of whom were good Brooklyn boys, either by birth or choice.

By exploring four of the major touchstones in a coffee bean's post-farm life cycle—its green state, its roasting, the cafés it's served in and its ultimate brewed consumption—this book aims to illuminate not only what coffee means to New York (and vice versa) but also the greater effect this

combination of place and product has had, and will continue to have, on the caffeinated world at large.

Of course, there are limitations to this work, as with any. To write *the* history of coffee in New York would be nearly impossible; this is instead *a* history—one of a million possible variations, built from long hours of reading, candid interviews, good and bad advice, a Bronx cheer or two and years of firsthand experience as a New Yorker in the coffee business. It will be at least a little out of date even the moment it's published, because New York and the coffee in it are always changing; every effort was made to keep up, up to the last. There will also be plenty with which a reader may disagree. New Yorkers love to argue, after all.

While New York's coffee history begins with the earliest settlers, this tale focuses primarily on the nineteenth century forward, with a few brief trips back to colonial times. It also avoids a long, in-depth look at the coffee plant's horticultural life story. There are many worthy texts covering coffee's origins, varieties, cultivation, processing and so forth; further reading can be found in the bibliography. Instead, this book aims to be a popular history focusing on the "asphalt terroir" that the Five Boroughs lend to coffee and the coffee industry. This history includes some of the quintessential local personalities who have shaped coffee in all its forms—green, roasted, served and guzzled. These characters may seem larger-than-life to everyone else, but New Yorkers will immediately recognize them as kin, despite—or perhaps because of—their flaws and/or failures. It also touches on some of the places that have meant the most, from the "Coffee District" to the Villages, both East and West.

Like any good *kaffeeklatsch*, this book will likely inspire a host of discussions, surprises, criticisms and good old-fashioned kvetching. I welcome all of the above and look forward to the chance to hash it out the best way I know how: over a cup of coffee.

1

GREEN

The Beans, the Market and the "Coffee Men" of Lower Manhattan

It might seem odd to start the story of coffee in New York by venturing outside of the area, but like many of the city's inhabitants, coffee is a nonnative, with faraway roots so deep and tangled that to ignore them is to ignore much of what coffee contributes to Gotham's very singular identity.

Coffee itself dates back to who-really-knows-when, and neither the beans nor the drink are indigenous to the Americas but, rather, Africa. Coffee plants were brought to this hemisphere for cultivation by imperialists and colonists starting in the mid-eighteenth century—first to the Caribbean island of Martinique and then practically everywhere else between the Tropics of Cancer and Capricorn, throughout the mostly mountainous regions of Mexico and Central and South America. The crop took so quickly to its new terroir that by the late 1800s, Colombia and Brazil were already dominating the coffee market. (They still do; the two nations vie with Vietnam for the status as the top three coffee-producing nations in the world.)

Without going *too* terribly much into detail about the growing and processing of coffee, there are some basic agricultural details that will lend insight to later Gotham-centric topics; we'll cover them briefly before returning to the topic at hand.

While more than one hundred species of the genus *Coffea* have been identified throughout Africa, the two most common and commercially viable are *Coffea arabica* and *Coffea canephora*. Arabica, generally considered the higher-quality of the two main species, is native to an area that encompasses parts of eastern Sudan and western Ethiopia; it grows best at high altitude,

in cool and shady climates and microclimates that enjoy moderate heat during the day and cool (but never freezing) nights. This weather slows the plants' maturation, helping the coffee develop nuanced and even delicate flavors. The other prominent species, *C. canephora*, is often referred to as Robusta coffee. These hardy, thicker-trunked coffee bushes thrive in sunnier and hotter conditions at lower altitude, where their development happens faster, more uniformly and in greater abundance than *C. arabica*. Though it's more resistant to disease and pests, Robusta also tends to taste less pleasant: Where good Arabica coffee tends to be soft and sweet, Robusta can have a harsh, almost rubbery quality in the cup.

New coffee trees are grown from seed or sapling and can take anywhere from eighteen months to five years to begin producing fruit suitable for harvest and sale. Despite the slow start, a well-cared-for plant has the ability to produce for twenty years or more, and viable trees as old as eighty or one hundred years have been recorded. The lag time between sprout and profitable harvest is one of the main causes of the market boom-and-bust cycles that have tormented coffee traders for centuries. In times of short supply, high prices inspire farmers to plant more coffee; when the trees are mature enough to bear fruit, the market floods with the new harvest, and the price plummets. "Approximately every seven years," complained one early coffee journalist, "the life of a coffee-planter completes this predestined cycle. Seven years are a long time, and memories are short. Men forget their mistakes, and make them once more."[1]

The coffee bean that is roasted and ground and brewed with water is actually the seed of the fruit that grows on these trees. Typically called a coffee cherry or berry, the fruit looks rather like a cranberry in size, shape and, when ripe, color. (Except for those that ripen to orange, yellow and, in rare cases, pinkish or purplish.) Most coffee fruit develops two seeds per, which are encased under the cherry skin and enveloped in a kind of sticky-sweet fruit gunk called mucilage. Once the cherry is picked (hopefully at peak ripeness), the seed, or bean, is removed from the pulpy fruit by one of many methods, including fermenting and sloughing off, or allowing the cherry to completely dry like a raisin and removing it as a husk. Finally, the coffee seed's parchment layer—sort of like the skin around a peanut inside the peanut shell—is removed, and the coffee is sorted, graded, bagged and tagged for export. This is called green coffee.

There are more than seventy countries around the globe that grow coffee—in North, Central and South America, throughout the Caribbean, across Africa and in parts of Asia and the Pacific Islands—and millions

of pounds make their way into the United States annually. Some will remain separate, sold as single-origin coffee, but most, like the population of New York itself, will be blended together, creating a mix of flavors and characteristics sometimes complementary, sometimes contradictory and always complex. There are elements of regional variance that contribute to a coffee's cup, as well as myriad other variables, such as the plant's genetics and its picking, processing and handling. There is no perfect agricultural or scientific way of unlocking the combination of influences that make a certain coffee express its disposition the way it does.

Coffee's grading and classification system varies depending on the origin, but since the 1930s, it has been standardized to catalog the different types of beans available on the market.[2] For many coffees, bean size is the chief characteristic for grade assignment: The "AA" in a Kenyan coffee's classification, for example, indicates that the beans are larger than AB-graded and so forth. Brazilian coffee is often sold by screen size, as it's sorted through sieves with holes of various specific sizes. While size doesn't always indicate quality (ahem), it does contribute to more homogenous development in the roasting machine—thus fewer headaches for the roasting professional. In addition to size and density, coffee, like math homework, is graded on the number of defects present. According to Henry A. Lepper, author of the 1931 U.S. Food and Drug Administration guidelines for grading coffee, which are still in use today, the grading of coffee is something of an art, "done by the trade on well-established principles, the result of years of experience" in identifying, isolating and keeping track of the number of faults within a composite sample from coffee sacks in a particular lot.[3] The graders tally defects—such as "quakers," or underripe seeds that roast unevenly or not at all; mold; "sailors," which float in a density test; bug damage; and fully or partially blackened beans—and use this information to determine how the coffee will be marked for sale.

As with most other things regarding coffee, however, Lepper wrote, "There is not a unanimity of opinion that all of these should be regarded as imperfections."[4] This inconvenient tendency to disagree was one of the motivating forces behind the establishment of the Green Coffee Association (GCA) of New York, a seminal trade organization whose primary role is to oversee and enforce contracts, provide insurance for green coffee buyers and sellers and mediate disputes over lot quality and contract fulfillment. (More on the GCA later.)

Until cup taste testing was developed in the nineteenth century, coffee was bought and sold by appearance alone. Traders, importers and coffee

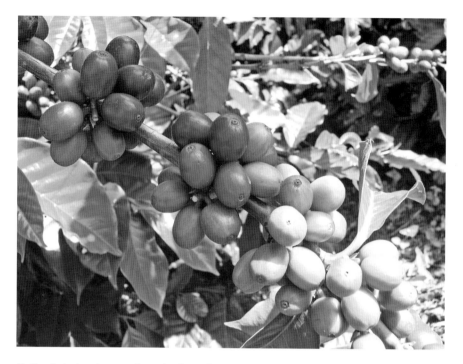

Coffee fruit ripening on a branch of a coffee tree in Colombia. *Photo by the author.*

roasters would inspect a selection of beans for coloration, texture and other obvious visual flaws and make deals before tasting a single drop. However, as anyone who has ever used an online dating service can attest, physical attractiveness does not always yield the most delicious results. Cup testing, or "cupping," is a means of preparing, brewing and sampling coffee liquid using an industry standard set of protocols that are not designed to highlight the coffee's quality but rather to reveal imperfections that are not always identifiable by sight. (Despite New York's dominance as a port city and the seat of the coffee market, the cupping process was born on the West Coast—one of many factors contributing to a great caffeinated American rivalry.)

In the cupping lab, merchants assess particular attributes of coffee's aroma, flavor and texture on the palate, inspecting it for its acceptability in different blends or anticipating its performance when roasted for retail or wholesale. Most coffee tasters look for uniformity within a sample, along with cleanliness, sweetness (which can indicate whether the coffee was picked ripe), acidity (the brightness, or fruity zing a coffee can have), body

or mouthfeel and the presence of pleasant flavors, as well as the absence of unpleasant ones.

Once graded, it is portioned out into jute bags—today, the coffee is often first put in a type of plastic bag designed for preserving grains, then into the jute—and organized in towering warehouse stacks, where it waits to be loaded for shipping by land, sea and/or very expensively by air. Finally, the coffee is available for sale.

Though coffee is a seasonal product, with specific harvest periods based on geography and climate, in its milled and bagged green form it's pretty sturdy stuff and will keep relatively fresh in a climate-controlled warehouse for many months—some say even years. For more than a century—practically until the invention of the shipping container (something else we'll come back to)—the general consensus was that fresh green coffee was inferior to aged, and certain types of coffee were intentionally stored in go-downs, or holding facilities specifically designed to "mature and season the coffee, which, like wine, improves with age…the flavor becoming richer and more mellow by the development of the volatile or essential oil contained in the beans."[5] Most contemporary coffee professionals disagree with this philosophy, but in those days of somewhat primitive coffee sorting and processing technology—combined with the rip-roaring state of pre-twentieth-century transcontinental shipping—the dulling effects of age on certain, let's say pungent, aspects of a coffee's flavor did sometimes act in its advantage.

This, of course, all comes before roasting—the process that transforms the coffee cherries' hard, greenish seeds into the aromatic brown coffee beans that we grind and brew.

With that vital information and context behind us, we're ready to explore the long and caffeinated legacy of New York City.

• • •

Officially settled by the Dutch in 1624, New York (then called New Amsterdam, for obvious reasons) was relatively slow to caffeinate by coffee, though the beverage was already known by the colonists, who had early contact in the homeland with spice traders from the Arabian Peninsula, who were the first to cultivate and sell coffee outside of its native Africa. It wasn't until the early eighteenth century that Holland's attention turned in earnest to coffee, however, when the Dutch established massive coffee plantations on

their colonial territories, most notably on the Pacific island of Java. Lucrative trade between Dutch properties encouraged the spread of coffee throughout western Europe in the eighteenth century—but we haven't gotten there yet in the story.

Rather, it was actually under English rule that the city really took to coffee, enjoying a brew reminiscent of the thick, bitter and heavily sweetened and spiced concoction favored by Middle Easterners—what we think of as Turkish coffee.[6] In 1664, the English claimed control of the city, rechristened it New York City (honoring the Duke of York, who later became King James II) and pushed industry and trade to new heights. The increased commercial activity meant more shops stocked exotic products like coffee and spices and stimulating ones like tobacco and tea. Green coffee was scooped from barrels and bags into greased sacks, ready to be pan roasted by housewives whose kitchen ceilings blackened with the smoke from scorched coffee beans. Come the second half of the century, people were already complaining about the price. In 1683, William Penn balked at having to pay eighteen shillings and nine pence for a single pound of green coffee in New York, the modern equivalent of nearly twenty dollars.[7]

Green coffee remained a luxury item, out of financial reach for most colonists, for nearly one hundred years. Since coffee itself provides no nutritional sustenance and was often heavily taxed to support imperial expansion, it was relatively easy for New Amsterdammers and early New Yorkers to view it as nonessential—a point of view hilariously contrary to that held by practically anyone who sits in a Midtown cubicle all day in the twenty-first century. As the colonies continued to develop, however, and incomes increased in the cities and towns, the allure of this energizing brew grew, and many households acquired specialized tools for roasting, brewing and serving coffee at home. By the early 1700s, coffee had become a staple import, though it was still largely traded by merchants who also dealt a variety of products like spices, sugar, chocolate, oatmeal and "sundry sorts of Goods."[8]

The second half of the eighteenth century saw an increasing aversion to all things British (e.g., tea from the Eastern territories) in the colonies, and enterprising traders began to capitalize on coffee and chocolate instead—what could be more American than taking advantage of sociopolitical ideals in order to make a profit? As the colonies began clamoring for independence from England, drinking coffee became a patriotic act, which was the first large-scale cultural boost to the beverage. After the Revolutionary War, there was no real turning back, and coffee became a more significant part of life

in New York. As of 1786, a half-dozen larger coffee-importing houses had set up shop along the waterfront streets of lower Manhattan. Five years later, there were at least a dozen brokerages dealing in green coffee, and the city's first wholesale roasting business had opened.[9] Coffee continued to be supplementary to other imports like chocolate and teas from Asia, however, and specialization in coffee was rare until the development of the modern coffee market in the mid- to late nineteenth century. "It seems strange," wrote longtime coffee trader Abram Wakeman in a 1914 book about the New York coffee district, "but there were more coffee importers in 1795 than in 1851, due to the fact that in the former years nearly all importing houses included coffee in their importations."[10]

Once specialized houses did emerge along the waterfront, Manhattan saw a booming increase in both coffee firms and their ampersands: Henry Coit & Son, J.L. Phipps & Co., Aymar & Co., William Scott & Sons, Hard & Rand and Kirkland & Gillett (which became Kirkland & Brothers & Co) to name a few.[11] Like most enterprises at that time, coffee was often a family business, passed down from father to son in name, title and learned experience. In his history of the waterfront coffee district, Wakeman remembered the rites of passage a young man went through in the trade if he wasn't born into it: "Every office had four or five boys to run on errands, at the salary of 50 cents per week, and we were expected to clean out the office every morning, draw samples from the warehouse, and pay, at the rate of 25 cents each, for the tea cups we broke. Sometimes our weekly salary would be worse than nil."[12] If a boy proved his worth, he was trained up as an apprentice salesman, an improvement in status that "was generally known by his appearance at the office wearing a silk hat and carrying a cane."[13] Many of the boys who found themselves taken under the wings of brokers and tradesmen came from fatherless homes or needed to work in order to support a struggling family—their hardscrabble go get 'em attitude earned many an errand-running neighborhood kid a later place at the table and, in many cases, an ampersand of their own.

Unlike the highly organized and largely digitized trade that exists today, lower Manhattan in the early days of the green-coffee trade was a kind of beautiful chaos of cobblestone-pounding salesmen, who would head out from offices along Front and Water Streets, meet ships at the docks to retrieve information and collect green-coffee samples and spend the day (or send an errand-boy) tramping around the neighborhood conducting "on the street business," showing off their goods, collecting bids and settling on a buyer at the close of the business day.[14] While competition was fierce—when

has competition not been fierce among New Yorkers?—there was also a prevailing sense of brotherhood among the "coffee men" and "jobbers," or wholesalers, who would often come to one another's rescue not only when it came to fulfilling coffee contracts but also in daily life. "There was a deep friendship between the members of the different firms," Wakeman wrote, recalling how the coffee men created their own sense of neighborhood on "the street," even as they fought each other for business in the houses:

> *In stormy weather, those having carriages would send to the offices of others inviting them to "ride up" with them, often stopping on their way....The younger set were members of the same social clubs. The ball game between the different trades was an annual event, the losing side paying for the dinners. The death in the family of one was mourned by all. The generosity of our merchants was proverbial the country over. Never was help asked by the writer for a good cause but sufficient would be quickly given and he was told, "If you do not get enough come and see us again."*[15]

New York businessmen have always seemed to recognize the inspirational power of keeping friends close and rivals closer, and instead of avoiding one another, the coffee merchants joined with members of other lower Manhattan trades to help found one of the city's earliest—and longest-standing, to the present day—private clubs, the Down Town Association. The club's atmosphere of civility and discretion made it a haven for the coffee men, and members from different brokerages dined, drank, read, smoked and played games together in the common areas and lounges; held meetings and conferences; and even lodged under the same roof in the clubhouse's private rooms.

Friendly rivalries played out at the poker and billiards tables just as they did in the stock houses and on the street, and despite their general congeniality, members of both the club and the business strove to follow the dogged example set by one of their own, the undisputed "King of the Coffee Trade": powerhouse broker Benjamin G. Arnold, who was a founding member and second elected president of the association, as well as one of the key players in the drastic modernization of the coffee market in New York (and, subsequently, the world).[16] Arnold was a Rhode Island native whose ambition, guts and tenacity made him an easy fit in Gotham. A maverick on the coffee market, he enjoyed astonishing success, experienced devastating failure and got a second chance so brilliant it could only happen in New York, the city of rebirth.

Arnold started as an accountant before getting a foothold in the grocery business, where he became known for "keeping his own counsels" and achieving success independently and rather privately.[17] A physically imposing man with a white chinstrap beard, thin lips and keen eyes peering through small wire glasses, Arnold was a bull in business but a more kindly figure in the coffee district, with a reputation for being especially generous to the gofers who ran to and from his office delivering news and samples. "My boy," author Wakeman recalled Arnold advising him early on, "always remember faces, do just what you are told to do, and you will get along all right."[18]

Accounts of Arnold's early experiences make frequent note of his ability to fly under the proverbial radar—"There is nothing special to record regarding the next fifteen years of his life," wrote one author—but by the 1860s, the former grocer had become a king. In 1868, he took control of the firm at which he had started as a bookkeeper, and by 1869, at age fifty-seven, he had more or less singlehandedly speculated himself $1.25 million richer on the coffee market by taking bold positions in stocks from Java, then one of the most significant coffee-producing countries in the world. (That number would be in the ballpark of $23 million today.)[19] Over the next ten years, Arnold formed a financially daring allegiance with two other major coffee firms: O.G. Kimball & Son and Bowie Dash. The resulting syndicate became known as "The Trinity," which would attempt a corner on coffee that forever changed not only "the street" in Manhattan but also the caffeinated world of business at large.

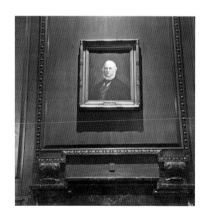

A portrait of founding member and first president B.G. Arnold overlooks the Presidents Room of the Down Town Association, one of New York's oldest existing private clubs. Initially a haven for coffee brokers in the district, it eventually became a haunt for lawyers, bankers and other Wall Street traders, as it remains today. *Photo by the author.*

By 1876, the United States was importing fully one-third of the world's coffee supply, bringing in an annual load of about 340 million pounds (worth more than $56 million).[20] Several factors made the business especially volatile: the vast quantities of coffee being traded, for one, as well as the reliance on physical stocks of coffee in warehouses (as opposed to harvest reports and forecasting) to predict supply and demand. This volatility was exciting

for gamblers but wildly dangerous, and the market lacked checks and balances to protect smaller businesses against the swinging pendulum of prices.

Unifying their buying power, the Trinity bought up the available stocks of Java coffee, artificially driving the price up and profiting on the exaggerated margins. Noticing the short supply and high prices, Brazilian coffee growers sought to capitalize on the lopsided market, planting vast numbers of new trees; by 1880, the enormous Brazil harvest had flooded the port of New York, sending green coffee prices—and the Trinity itself—into a spiral. It came as a complete surprise. Private sales on the street had made it impossible to track the volume of contracts being passed around, and lack of reliable communication with coffee-supplying countries limited access to information about the total poundage expected at the end of the harvest. All three firms and many of their associates failed as the cost of coffee plummeted, and business screeched to a halt as traders became suspicious and fearful of one another.

Realizing that the risk of conducting business this way had become too great, in 1881, some of the hardest-hit firms agreed to institute a public coffee exchange—like the Chicago Board of Trade (operating since 1848), as well as New York's oldest commodity market, the Cotton Exchange (1870)—to prevent future collapse.[21] Instead of being at the mercy of the boom-or-bust harvest patterns, a public coffee exchange would allow traders to buy and sell futures contracts—in other words, "paper coffee," not coffee coffee—redeemable for coffee grown and shipped at a later date and priced according to a rate established by committee, shared publicly, and which fluctuated according to environmental factors and forecasting. While the beverage is consumed year-round, agriculturally, it has limited and relatively inflexible harvest periods based on geography and climate. Rather than put both producers and consumers at risk conducting sales solely at the prevailing current market, a futures exchange establishes the ability to hedge, or to buy and sell contracts for lots of coffee to be harvested later.[22] (A "lot" is the contractual equivalent of 250 bags, each containing roughly 132 pounds of green coffee, though bag size and bag count varies by country of coffee origin.) The contract specifies the quality of the coffee, as graded and categorized against accepted standards—many of which were established by general industry consensus and observed on a kind of honor system before being more formally overseen and enforced by entities such as the Green Coffee Association.

Futures contracts allowed traders to protect themselves, as they were bound with one another and with exporters by contract, guaranteeing a

specific amount of coffee upon delivery and allowing for the open buying and selling of the contracts as insurance against price swings.

In an article about the value of the coffee futures market, University of Pennsylvania instructor and PhD G.G. Huebner concisely described the importance of hedging to a trader: "When the time for delivery arrives it is simply a question of calculation of the market conditions whether it is more advantageous to repurchase the sales made as a hedge, or as a kind of insurance to protect themselves against loss, and free the coffee so engaged, or to make delivery of the coffee as it comes in."[23] (He makes it sound so easy, doesn't he?)

The establishment of the New York Coffee Exchange is a typical example of the city's ability to emerge from its own rubble tougher and smarter, and the fact that the institution's first president was one of the brokers whose failure had created the need for the exchange in the first place is evidence of the Empire City's love for a rags-to-riches-to-rags-and-back-to-riches story. From among the eleven incorporating members of the new Coffee Exchange, B.G. Arnold, barely two years removed from what looked like utter financial ruin, led the new market in its opening day of March 7, 1882—though the first call was received rather tepidly, "not only by the trade, but by the members, less than half of them being present."[24] The initial joining fee was $250, and it took some doing to convince coffee men to come on board, as the trade was still smarting from the damage done in 1880. Even Wakeman, a regular booster among the coffee men, understood and empathized with the general skepticism about the Exchange on Front Street and in the coffee district: "Perhaps, after all, it would have been better had there been no Exchange and we had gone on doing business in the same old way; but the world moves on, I am afraid, even the grand old coffee merchants could not have made it stand still. It was to be and is."[25] A single 250-bag sale was made that first day, but the Exchange slowly gained steam as interest in the coffee business rekindled, and membership grew. By 1904, the floor had become a lively enough place to inspire at least one melodramatic novel (*The Corner in Coffee* by Cyrus Townsend Brady), and the Exchange did eventually prove itself pivotal in stabilizing the coffee market through open-outcry trade; creating checks and balances on trade principles; establishing and enforcing standard classifications of goods delivered against contract terms; offering brokers and growers alike the protection benefits of hedging futures contracts against the current market; and creating a platform for the distribution of information and the collection of data about the global landscape of green-coffee trading.[26]

Longtime New York specialty merchants Joel, David and Karl Schapira wrote succinctly about the elements of the green-coffee business, which have improved on a parallel line with the advances made to the Exchange. "The advent of intercontinental cables, the telephone, and fast sailing ships curtailed artificial manipulation of coffee," they assert in their 1975 *Book of Coffee and Tea*. "Shipping schedules became well known and information about conditions affecting the crops, such as adverse weather or strikes, was at hand. Prices began to reflect conditions in the producing countries, rather than the available supplies in the consuming countries."[27]

In 1914, sugar contracts were added to the market, and the name was officially changed to the New York Coffee and Sugar Exchange in 1916. By 1935, there were "312 brokers, importers, dealers, and roasters" on board, and membership was worth $4,000 a head, cementing New York's position as the long and uncontested leader in the global coffee trade.[28] In the late 1970s, cocoa joined the futures trading, and the New York Coffee, Cocoa and Sugar Exchange became the largest market of "dessert commodities" in the world.

Part of the impetus behind building a sophisticated market for coffee trading in New York was to establish the city as the seat of the industry, which, along with its strategic entry port and access to vast interstate rail travel, was an obvious development as the coffee economy boomed. Important but far smaller international markets existed in France and Germany, and New Orleans and San Francisco—the other major ports of entry for coffee shipped to the United States—conducted coffee sales on local markets as well.[29] New York continued to dominate, however. By the 1960s, more than 40 percent of U.S. coffee imports were passing through New York customs annually, with New Orleans a distant second (around 20 percent).[30]

The buying and selling of futures contracts is one significant aspect of the Coffee Exchange, and in addition to its functionality for these large transactions and hedging, it also serves as a kind of protection for the "spot" market, or the sales that happen "on the street" between importers and roasters or other dealers. Spot coffee is, as the name implies, available for purchase on the spot, as in coffee that's already arrived and is physically available for delivery. Spot sales are private transactions between businesses, and while their prices are not dependent on the "C" market (the fluctuating base price per pound for green Arabica coffee, set by the Exchange), they are often informed by it, as well as other trends displayed by industry actors.

Spot brokers were the men pounding the pavement in the coffee district, selling actual physical product to wholesale jobbers or directly to roasters.

Until relatively recently, the scenes that played out along Front, Water and Wall Streets in lower Manhattan hadn't changed much since Abram Wakeman's day in the late nineteenth century, when he was a boy running from firm to firm to deliver messages to the likes of B.G. Arnold and O.G. Kimball. In the 2000s, looking back on the early days of his fifty-plus-year career, New York coffee trader Julius Kahn remembered, "We had these metal trays that carried about three-quarters of a pound of coffee. You'd walk along Front Street," and by sheer virtue of shoe leather and charm try to finagle the best and the biggest sale of the day.[31]

Prior to the Green Coffee Association's establishment in 1923, "Green coffee, which had been coming into the United States for well over a hundred years, was handled in a catch-as-catch-can fashion," recalled Abba Bayer, a nonagenarian former trader with New York's W. Phyfe & Co., who served on the GCA's board of directors more than a few times in his nearly sixty-year career.[32] In a legacy-preserving video produced in the 2000s by the GCA, Bayer explained, "Coffee came from countries that were very underdeveloped and [the coffees] very often were not what they were supposed to be." Unscrupulous merchants would frequently mislabel, repackage or blend "ship sweepings" in with fair or good-quality coffee in an effort to dupe the buyer. To dissuade dishonesty, the Green Coffee Association contracts held specific sampling and examination procedures in place, which would allow a purchaser to dispute the condition of the coffee he received, based on the expectation of the contract.

New York's relatively easy access to the Atlantic, extensive network of piers and warehouses and close connection to interstate and intercity roadways made it a natural hub for the green-coffee trade from the beginning and the primary entry port for most of the industry's early American history. "In 1934, the New York Dock Company alone had 105 storage warehouses, both bonded and free, having a total capacity of more than 44,000,000 cubic feet; and 34 piers, the longest measuring 1,193 feet and containing more than 175,000 square feet," wrote William H. Ukers in his seminal industry textbook, *All about Coffee*.[33] Unloading that stock was a big task for big men. "Coffee came in slings like you saw in *On the Waterfront*," recalls eighty-four-year-old second-generation coffee man Sterling Gordon, founder of one of the East Coast's largest green and roasted businesses: Staten Island's Coffee Holding Company. Longshoremen would hoist sacks onto the dock in huge slings, carry them shoulderways and drop them into demarcated "chops" in the warehouse, where the stacks were separated by grade and consignment. Samples were taken as soon as the loads were organized. Warehouse staff

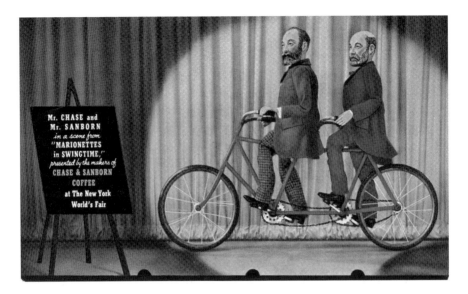

The 1938–40 World's Fair in New York was sponsored in part by the large local coffee company Chase & Sanborn. Coffee Day was also sponsored by Chase & Sanborn and held on August 31, 1939 (fittingly, the same day as the author's birthday). *Author's collection.*

used long metal triers (sampling instruments resembling apple-corers) to stab into the burlap and remove a small amount of green beans from several or even all of the bags in a lot to compile a representative sample, which allowed cup tasters to compare the quality of the physical coffee against the terms of its contract.[34]

"And of course, they swept up the coffee that fell on the floor, and it was sold," Gordon says with a wink. "If it was in the hull of the ship, it was called 'ship fills,' and it was roasted in America. But if it came off a foreign-flag, you had to export it."

Low prices and the emergence of new coffee-producing countries such as Kenya and Angola in the 1930s drove the coffee men to advertise more aggressively, undermining much of the conviviality of the district but steadily improving sales to consumers. When the outbreak of World War II closed most European markets to coffee imports, supply and demand enjoyed simultaneous surges. In 1939, more than 15 million bags were brought to the U.S.A., and by 1946 the annual demand was 20.4 million bags. In 1949, American coffee imports peaked at more than 22 million bags.[35]

As Americans' per capita coffee consumption increased, business on the street became more competitive. New York itself was bursting on all sides around the coffee district as industry and population surged, and commercial

consolidation seemed the only way to scale in order to meet both growing demand and growing bureaucracy regarding consumer goods in times fraught with economic depression and war. "During the Second World War, when Washington was administering controls, there were 3,764 orders and regulations governing coffee during 1942 alone," wrote commodity specialist and longtime Exchange member Bernard Colodney in 1959. "The average coffee man had one foot in his home market, one foot in Washington, and one foot in his mouth."[36]

Though Americans' coffee-drinking habits continued to soar after the war, coffee supplies dwindled as a result of European markets reopening to imports, as well as weather-related reductions in global yield—a combination that had profound effect on the market. Frost in Brazil virtually decimated that country's harvest for the 1953–54 season; the effects were felt through price increases over the following few years, "and then it began feeding on itself," Colodney wrote. For the first time, consumers were being charged more than $1.50 a pound for roasted coffee, and many began drastically watering down their recipes to stretch their supply. Some switched to cheaper brands filled out with low-quality beans or blended with chicory, and others still moved on to instant coffee, often made from inexpensive Robusta.[37] Between 1959 and 1969, Robusta skyrocketed from 9 percent to 26 percent of green-coffee imports; in 1969 alone, imports of soluble (instant) coffee

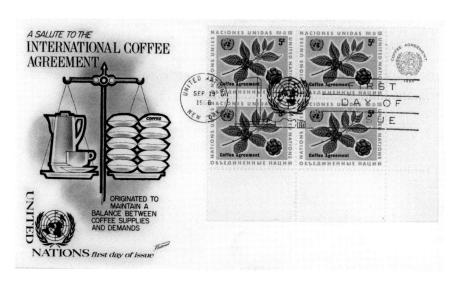

First Day of Issue commemorative stamps, recognizing the 1966 International Coffee Agreement, an attempt to balance supply and demand to stabilize green coffee prices. *Author's collection.*

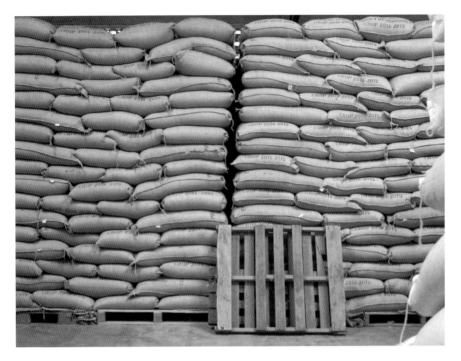

Coffee bags stacked in a warehouse, ready to be sold for roasting. *Photo by the author.*

increased by more than 400,000 bags, while green-coffee imports declined by 20 percent in a single year.[38]

Around the same time, the invention of the container ship for cargo in 1956 revolutionized the transportation of coffee, replacing the space- and time-inefficient break-bulk shipping that left coffee sacks exposed to the elements and vulnerable to damage and mold. Such ships were also much more labor-intensive to load and unload for delivery, and the work was slow. Containers were more climate stable, emptied in less than half the time as a break-bulk ship and could be hoisted directly onto trucks or rail cars headed west, vastly improving and increasing the coffee market off the coasts.[39]

To accommodate the new technology, the New York Port Authority almost immediately began construction on the world's first fully containerized shipping port, open for business in 1962—but it was across the Hudson River in New Jersey, further cementing what might be the worst case of state sibling rivalry in the continental United States.[40] No longer could the New York coffee brokers simply walk or taxi down to the ports to collect their

samples, which eliminated much of the usefulness of having a condensed coffee district along the waterfront.

The business became more abstract. More trading took place on the Exchange, or by mail and phone, which could be done virtually anywhere. Brokerage houses closed, and importers consolidated and merged or were acquired by multinational corporations dealing in various commodities. By 1980, the coffee district in Manhattan's waterfront downtown had virtually disappeared, as the remaining companies relocated to the outer boroughs.[41] The market itself became increasingly global and almost entirely online by the start of the twenty-first century. The futures market of the Coffee Exchange itself is no longer centralized in New York, as it, along with many other individual commodities markets, was folded into the Intercontinental Exchange (ICE), a global electronic trading platform launched in 2000, leading to the eventual elimination of open-outcry, in-person trading (2012).

The instantaneous relay of information regarding supply and demand, environmental conditions impacting yields in producing countries, currency rates and the fulfillment of contracts has certainly continued to stabilize the market, but it also has "changed the complexion of the business," says Sterling Gordon. "Years ago on the Exchange, a big day might have been five or six hundred bags. Today, they do that in 5, 10 minutes. Not only is it electronic, but funds and speculators have gotten involved. Not only in coffee, but most commodities. It gives breadth and depth to it, but at the same time, coffee still to some extent depends on weather—drought, frost, etc."[42] The disconnect, Gordon explains, has made the trade less tangible— different from the hands-on brokerage he remembers, which was also the world in which his father worked, selling green coffee out of a horse-drawn wagon to jobbers who peddled imported goods like olive oil, pasta and dark-roasted beans for espresso to mostly Italian markets.

Despite being scattered around the New York metro area, there still exists in the local coffee industry the type of quasi-brotherhood and kinship Abram Wakeman remembered from his days "on the street." "The coffee business in New York is that way," says Donald Schoenholt, owner-operator of the oldest coffee merchant not just in the city, but in the country: Gillies Coffee Co., with which we'll get better acquainted in the next chapter. "We're old family businesses. We watch each other, and we know each other and for the most part we like and respect each other, and we wake up every morning and try to take each other's customers."[43]

The virtual nature of the contemporary futures market and the less hands-on daily dealings of the spot market in the global coffee industry

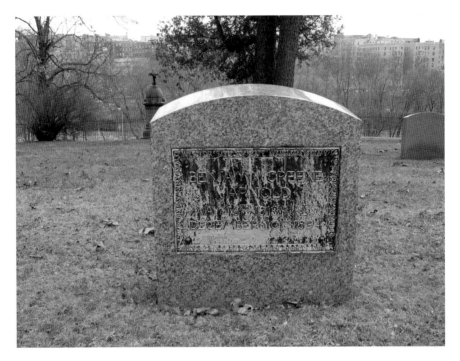

B.G. Arnold's final resting place, in Woodlawn Cemetery, Bronx. *Photo by the author.*

has obscured New York's long influence over the world's caffeine supply, but the legacy remains. The Green Coffee Association of New York, which still oversees and enforces a majority of American coffee futures contracts today, lost its historical archives in the attacks on the World Trade Center in 2001 but has worked to compile an oral and video history featuring some of its oldest and most storied members. In some of the city's longest-standing cup-tasting labs, the old metal sample trays are still used, the names of the old brokerages fading but visible, ampersands and all. And while the Coffee District is no longer downtown, anyone willing to endure a long subway ride may pay respects to the Coffee King: B.G. Arnold's final resting place is in Woodlawn Cemetery in the Bronx, quite possibly and perhaps ironically the borough in which a good cup of coffee is hardest to find.

2

ROASTED

Alchemy, Marketing and Chock Full o'Personality

The transformation of a green coffee seed to plump brown coffee bean is nothing short of alchemy—in fact, that's exactly what drew Muslim traders to coffee in the first place, its embodiment of the mystical process God uses to turn something useless into something sacred.

The raw seeds themselves bear a hint of resemblance to those in their finished state, like an artist's rough sketch before he sets paint and brush to canvas. They smell sweetly grassy and look and feel like small river pebbles: hard and dense, heavy for their size and in varying shades from yellow-green and green-grey to almost blueish, depending on variety and process. They are loaded into a roasting machine that tosses them around in hot air, and then the magic begins. First, the heat seeps in through the outer layer of the seed, reaching and reacting with the moisture and nutrients inside. That moisture begins to evaporate, and the seed turns a slightly amplified green—think of blanched versus raw peas—then a bready yellow-brown and, after a few minutes, a golden color that indicates the caramelization of sugars and development of flavor. The human standing at the roasting machine, who has perhaps been watching this process out of a sideways eye, will start to pay keen attention, typically using a pull-out scoop called a trier to quickly remove and inspect a small sample of coffee throughout the roast. A well-trained nose hovering close enough to the beans not only smells them but also feels the heat and vapor rising off of them, judging in an instant the speed and progress of the job. At this stage, the beans are

A coffee bean, once roasted, will nearly double in size but loses about 16 percent of its weight due to moisture evaporation from the development in the roasting machine. *Photo by the author.*

a cinnamon color and smell of caramel; they turn milk-chocolate brown, then the color of cocoa powder, and their round backs begin to smooth out until they are nearly double their original size. Suddenly there is a pop, then another and another, followed by a rolling crackle as the beans expand and begin to release the heat that has been captured inside them. This is called "first crack."

They continue to tumble around, and the popping slows and stops; the coffee beans turn a rich umber, and a second, softer popping is heard as the coffee's cell walls splinter under the continued pressure. This is "second crack." The longer the coffee is left in the hot roaster, the darker and oilier it will appear. When done, the roasting master drops the still-steaming beans into a large tray to cool them as quickly as possible.

Roast*ing* coffee smells rather unlike roast*ed* coffee, and it is an acquired smell. There's an almost acrid edge to it, reminiscent of the scent of burned chocolate chips floating above the sweeter, simpler aroma of the cookies themselves. It's rich and nostril-filling, and it covers everything—to the

displeasure of many neighbors. "To some, that gorgeous harmony is just a bad smell; loudly they complain. That violet haze hanging over [the Coffee District] they brand a smoke nuisance," reported the *New York Herald Tribune* in 1948. "The coffee roasters, to avoid trouble, are working on a device to eliminate pollution, a sort of incinerator which can digest smoke, odor and chaff. Once that gets into good working order, we aren't visiting Water Street ever again; its character will be lost."[44]

The character of Water Street and its surrounding district has certainly changed, and the smell of roasting coffee no longer covers the air there. (Not only because there aren't any roasters in the area but also because of the invention of the roaster afterburner and other smoke-eliminating innovations.) Still, when the wind blows just the right way—often in the dewy early morning—you can still snatch a whiff of roasting coffee floating over the East or Hudson Rivers. The vast majority of the work is now done off Manhattan island, where zoning laws, and perhaps the neighbors, too, tend to be more…relaxed.

Coffee roasting is something that's easy to do but difficult to do really well—not unlike *brewing* coffee, actually. Anyone can pour hot water on grounds and make a coffee-flavored liquid, and just about anyone can apply

Roasted coffee, ready for blending, bagging or brewing. *Photo by the author.*

31

heat to green coffee seeds and cause them to turn brown. In fact, it wasn't until the early nineteenth century that coffee roasting began to come out of the frying pan—literally, since housewives browned (or blackened) the family's beans in metal skillets over stove fires—and into the factory. Before the invention of more modern and industrial equipment in the 1860s, finding roasted coffee for sale was relatively difficult, and the average New Yorker roasted at home or drank brewed cups at coffeehouses and the smattering of restaurants that were opening up downtown. Green coffee was sold from burlap sacks alongside flour and sugar in general and dry goods stores, often custom- or house-blended and scooped into greased bags.

That coffee roasting is so difficult to do well is one truth that shaped much of the early industry in New York, and it is also one reason you probably have never heard of most of the companies responsible for millions of the city's daily cups. For most of the history of New York's coffee industry, trade and toll roasting was a big business. Companies wishing to establish themselves as coffee-selling brands would hire an outside company to blend, roast, package and sometimes even source the green beans under a private label. Roasting equipment was expensive and troublesome to operate, and zoning laws and real estate woes meant it was far more economical to outsource much of the process. Few New Yorkers realize how many of their favorite blends and brands are still roasted by some of the longest-standing firms like Gillies Coffee Co., the oldest by far, dating from 1840; White Coffee, founded in 1939 and still in operation in Queens; Coffee Holding Company, formerly of Brooklyn and currently on Staten Island, founded in 1971; and Barrie House Coffee in Mount Vernon, just north of the Bronx.[45]

Scott Tauber is third generation in the coffee industry, and, like the two generations before him, he is 100 percent steeped (or brewed, more like) in the city.[46] His East New York stomping ground looks nothing like the Gotham found on postcards—in fact, aside from locals and the employees at the factories out here, most residents of the Five Boroughs wouldn't be able to point it out on the map—and its location just a few blocks north of the Belt Parkway lends nothing to the physical or aural scenery. In a nondescript building on Berriman Street (the building is barely marked, but with a faded sign on the door), Tauber oversees the roasting, blending and packaging of hundreds of pounds of coffee at a clip, all bagged and boxed and delivered under one of the city's oldest brands, if by lineage alone: Hena Coffee Inc.

You've never heard of it, and that's the way it's supposed to be. Hena, like the coffee business Tauber's father, uncle and grandfather ran before it, was designed to be a behind-the-scenes player in the story of New York

coffee—a fact that Tauber is slowly trying to change, thanks to the more modern crush of the competitive coffee market.

It would be a miracle of modern literature to capture Scott Tauber's voice: warm but teasing, with the classic lilt and explosive hard consonants that are typical of local natives. Words pop out of his mouth like the crackle of the beans as they develop under the heat of the roaster, and he lets them fly, fast and full of opinions.

Tauber's grandfather was Harry H. Wolfe, a longtime coffee man who learned the trade as an apprentice roaster for Joseph (allegedly the inspiration for "cup of Joe") Martinson. Wolfe roasted for Martinson's Coffee from 1911 until he joined the navy in 1917; a few years after the end of World War I, he founded his own coffee, tea and chocolate company in 1923 in a building stocked with enough modern equipment to roast "more than 10,000 pounds of coffee daily."[47] By the time Tauber's father and uncle made the business a family affair in the 1940s, Harry H. Wolfe & Son was focused entirely on coffee roasting, dropping the tea and chocolate and becoming one of the area's largest caffeinated concerns. By the 1970s, says Gillies Coffee's Donald Schoenholt, "There were seven (count them, seven) four-bag Jabez Burns R23 roasters at Wolfe's 3rd Ave Brooklyn plant," which roughly equates to "a roastery yield capacity of 350,000 [pounds] in a 35-hour week."[48]

"What they were was trade roasters—never sold a bean of coffee. All they did was to provide the service of roasting, grinding and packing to your needs, whatever they were, from the late '40s till almost '92," Scott Tauber says. Customers would choose the blends—many of which remained secret and proprietary—and Wolfe & Son would roast to their specifications. "We sold a service, and we did work for probably all the coffee companies that pretty much exist in New York today." There were never Wolfe & Son coffee shops or even a single bag sold under the family name. Like most of the trade roasters, they avoided creating competition with their customers, which included some of the city's most prominent coffee brands.

When they came of age, Scott Tauber and his brother, Lanny, decided to stay in the coffee business—but not solely as for-hire roasters. Instead, they founded Hena Coffee in the late 1960s, sharing a plant with Wolfe & Son when it moved to Third Avenue in Brooklyn's Gowanus neighborhood. "We started selling coffee down the street in burlap bags, twenty-five-pound bags to anybody who wanted it. Really, gourmet-to-go-home kind of a thing," Scott Tauber says with a shrug.[49] He and his brother watched their father and uncle's business diminish in the 1980s as their customers began handling

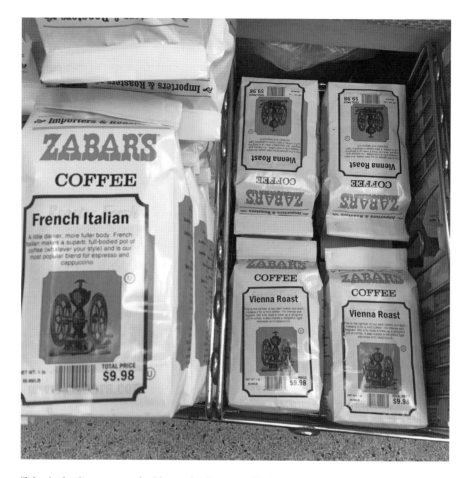

Zabar's classic orange-and-white packaging on coffee bags in the store. *Photo by the author.*

the task for themselves to cut costs. When Wolfe & Son closed its doors in the '90s, it was the largest remaining trade roaster in the United States.[50]

Tauber is not what a coffee snob would consider romantic, but there is a certain lyricism to the way he describes his work. (The Upper West Side's famous Zabar's Market's coffee, for instance, is roasted by Hena; owner Saul Zabar is notoriously passionate about coffee, which is itself a recommendation for the trade's services.)[51] "We do the Colombian, the Guatemalan, not a lot of Mexican, we do Ethiopian, Java, Sumatra, decafs and then we take those coffee [beans] and roast them many different ways, different shades," Tauber says, sort of drawing in the air with one hand. While Hena does some toll roasting and maintains its own back-of-the-

house products—the kind of coffee packaged in plain foil packaging, sold for its quality and consistency, not its brand-name appeal—Tauber has been working on a line of more customer-forward coffees, capitalizing on the popularity of specialty coffee and the obsession with all things Brooklyn. He hopes that Hena's new Brooklyn Coffeehouse bags will help bridge the generation gap between the era of the trade roaster and today's fascination with microroasters and upscale beans.

"I don't sell as much specialty coffee as the rest of the world, because I don't have the marketing, and the people who sit there and do the Internet and the Twitter and all of that," he says with a shrug. "It's not in my wheelhouse. So I give good quality coffee for what I give, I give good blends."

Out in the relative boonies of East New York, it's easy to remain oblivious to the fact that a company like Hena is turning over thousands of pounds of roasted coffee a day. Before downtown rents spiked and pushed the coffee men out to the outer boroughs, however, lower Manhattan was constantly enveloped in the aroma of roasting coffee—and surely if the city itself wasn't so loud, passersby would have been able to hear the simultaneous popping of tons of beans hitting first crack. Whether it was belching out of machines roasting six hundred pounds at a time or from sample roasters used for preparing small amounts for cup-testing, the coffee smell was unmistakable. It came from the trade roasters as well as from the massive brand houses such as Savarin and Martinson in Manhattan; Arbuckle's Coffee, Chock Full o'Nuts and Ehlers in Brooklyn; and the midsize local companies that crowded the region until the 1950s, when the rising cost of real estate forced en masse relocation to the outer-outer boroughs. (The final nail in the coffee coffin, Schoenholt says, was an expansion program the city undertook in advance of the 1964–65 World's Fair, which "put many roasters out of business, and drove others away.")[52]

"We have been unable to really make the jump across the river, psychologically, to the Jersey side, so we still think of ourselves very much as a New York company," says Steven Kobrick, third-generation owner of the four-generation Kobrick Coffee Co. The eponymous company was founded by Steven's grandfather Samuel in 1920, and by the 1930s, it was an established part of a cluster of multigenerational New York coffee firms that were both competitors and friends—including the families behind Gillies Coffee Co. (1840), White Coffee (1939) and, out in Ozone Park, Queens, the Russian-immigrant siblings behind Dallis Bros (1913). In the 1980s, the Kobricks faced a tough decision to sink or swim as the Coffee District vanished around them, and they decided to swim—right across the river

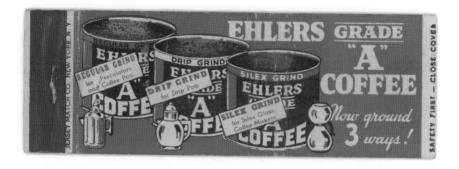

One of the large regional coffee roasters and distributors of coffee, tea, tobacco and spices, Albert and Katie Ehlers' eponymous company was founded in 1920, with capital of $300,000. The company was eventually acquired by a large local competitor, Greenwich Mills. *Author's collection.*

The original Kobrick Coffee Company location, now hardly recognizable but for the label scar. *Courtesy of Kobrick Coffee Company.*

to Jersey City, New Jersey. "We were one of the last sort of sizable roasters, somebody working with like a four-bag roaster, that was still in Manhattan. Everybody else had sort of been pushed out or ended up moving."[53] (The "four bags" Kobrick mentions means four full-size jute or burlap sacks of green coffee, each weighing roughly 130 to 150 pounds.)

Steven Kobrick and his late brother, Lee, came into the family company in the 1980s, when their father, Frank, began to suffer ill health; together,

they decided to supplement the Kobricks' institutional work supplying offices and other large facilities by adding a smaller roasting machine alongside the industrial-size four-bag Jabez Burns unit they'd used to turn over large batches for decades. The smaller and more specialized equipment allowed the brothers to experiment with roast profiles and explore different, more limited coffees, which helped the company appeal to some of the city's fine-dining establishments (like those of celebrity chef David Bouley) and more upscale cafés. "In order to be relevant, and in order to create a future for the generations to come, we have to break out of the back of the house," Kobrick says. "It means that we need to create a brand awareness for our company's history and the values that our company represents, which has always been focused on quality and always been focused on craft."[54] A recent logo and packaging overhaul, and the 2016 opening of the company's first coffee and spirits bar in Manhattan's fashionable Meatpacking District, are the direct result of the next wave of Kobricks coming up to take the helm. Lee's children Nicole and Scott are largely responsible for the updates, and their uncle sees the new direction as the company's means of survival in a competitive market. Without being able to operate under the company's own name, Steven Kobrick says, recognition would continue to be more and more difficult: "New York had a very shitty reputation for coffee, and it was clearly because of the fact that [local roasters'] customers were not showing a proper level of respect for the product, and understanding that it requires a level of craft, that was on an equally high culinary level to what they were doing with their food and dessert menus."

Even as the New York coffee scene becomes less family company–oriented and more aggressive, Kobrick and his family believe that the local industry's long history of good-natured tug of war continues and pushes quality up overall. "There were several competitive companies, and there were some rivalries, but my view of the business is that it's been extremely friendly. I have warm relations with all of the roasters that I know, and I value that a lot. I always felt as though it was nice, it was a good group of people, it was nice to have that appreciation for each other and the ability to set aside the fact that there was a lot of competition for the business, and that the people basically got along pretty well."

"Speaking of which," he stops to ask, "have you spoken to Donald yet?"

This was literally the first question anyone asked in response to my requests for interviews and stories about coffee in New York. "You should really talk to Donald," or, "You'd have to ask Donald," is apparently the New York–coffee equivalent of pleading the Fifth Amendment. In fact, Donald Schoenholt's

Samuel Kobrick, founder of the Kobrick Coffee Company, celebrates with family. *Courtesy of Kobrick Coffee Company.*

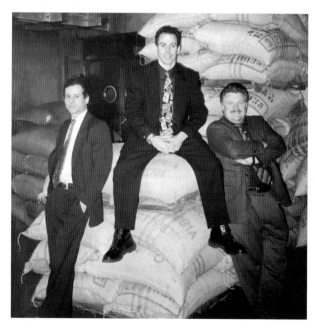

The coffee men of Kobrick Coffee (*left to right*): brothers Lee and Steven and their father, Frank. *Courtesy of Kobrick Coffee Company.*

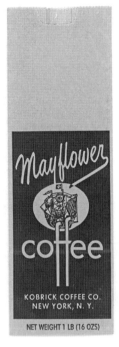

Far left: One of the Kobrick Coffee Company's signature blends, Mayflower Coffee has been in manufacture for generations—and continues to this day. *Author's collection.*

Left: Mayflower Coffee bag, reverse, with brewing instructions. *Author's collection.*

Below: A longstanding version of the Kobrick Coffee Company logo. *Courtesy of Kobrick Coffee Company.*

A cupping at the Kobrick Coffee Company facility, on a Jabez Burns cupping table; note the balance in the center, traditionally used to weigh out coffee samples to the equivalent of a nickel and a dime. *Courtesy of Kobrick Coffee Company.*

Lee Kobrick in the Kobrick Coffee Company production facility. *Courtesy of Kobrick Coffee Company.*

name came up so often—in stories told by his peers, in secondary sources, as well as in a host of articles both by and about him—that I'll admit I began to wonder why he wasn't the one writing this book.

Donald Schoenholt, president of Gillies Coffee Co., is a born coffee man, and he'd be the first to describe himself that way. "I didn't come to this by accident," he says of his life's work, which he inherited from his father, David. "I was born up in it. If my father had been a fisherman, I'd now be a fisherman."[55] While he's not quite a fisher of men, either, Donald has certainly been something of a shepherd for specialty coffee. He was a co-founder and early president of the Specialty Coffee Association of America and the founder

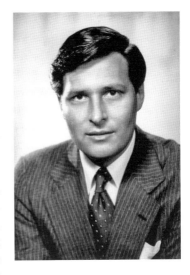

Donald N. Schoenholt, president of Gillies Coffee Company, 1981. *Courtesy of Donald N. Schoenholt.*

and first president of the Roasters Guild and continues to be a funny and opinionated voice any time someone needs or wants a smart and sophisticated sound bite about coffee. "I'm a one-trick pony. I don't think about much else," he says, reflecting on how much of his seventy years has been spent obsessing over the little black drink. "But if you think about coffee eighty-three different ways, it can pretty much take up your whole life."[56]

By most accounts (Schoenholt's included), Gillies Coffee Co. is the oldest extant coffee merchant in the United States. The company was founded by a farm boy turned tea clerk named Wright Gillies, who moved down to the city from rural Newburgh-on-Hudson at nineteen years old. In three short years, he had stepped out of apprenticeship and into a new role as business owner, opening a company that "sold its coffee, tea, cocoa and spices to inns, taverns, institutions and clipper ships" starting in 1840.[57] By 1848, Gillies had been joined by his younger brother James, and the pair roasted coffee on their own horsepower apparatus in the courtyard and made deliveries by cart. The company became Gillies & Bro. and that same year "opened a wholesale department selling direct to the consumer and family trade in lots of five pounds or more."[58] The company saw myriad ups (James was awarded a major patent for a roaster cooling system in 1871) and downs ("If you were a nineteenth-century coffee company," Donald

says, "you could expect to burn down every five years or so") but endured and "arose the stronger for the experience."[59] Wright retired in the 1880s, leaving James at the helm; James's children continued the business after his death in 1899, incorporating as the Gillies Coffee Co. in 1906, the name that remains today.[60] The firm struggled to survive in the first half of the twentieth century, as James's son broke off from the family business to start his own company with a college chum, leaving the Gillieses without male successors in an industry that was purely XY chromosomal.

Coffee was an inherited trait with the Schoenholts, as well. Donald's uncle Mac was established in the industry in the 1910s; in 1927, his younger brother David L., Donald's father, followed him into the trade. David L. took control of the Gillies Company in 1947, and his experience and good sense would grow the wholesale and retail presence throughout the boroughs. In 1953, the company expanded to a 17,500-square-foot roasting and packing plant, moving out of the space it had occupied for 113 years on Park Place and Washington Street—an intersection that no longer even exists, as streets were interrupted to develop the Financial District.[61] David passed it along to his own young son somewhat unexpectedly in the 1960s, the result of poor health on the part of the elder Schoenholt. For better or worse, Donald's commitment to coffee—and tradition—was already ingrained when he became Gillies's head coffee man. "We're a nineteenth-century business, and as much as possible I want to do things in a nineteenth-century way," he says, over the roar of the roasting machine and the whir of the packers.[62]

The company has been in continuous operation, and in a family way, for seven generations, and it is still very much a legacy business. Schoenholt says that of the company's fewer than thirty employees, most have been around for fifteen years and some as many as twenty. His business partner and childhood friend Hy Chabbott came on board in the mid-1970s, and he and Donald tease and bicker like a married couple in an old Sunday comic strip. Business has grown—that expansion in the 1950s, for instance, and a handful of successful retail stores in the 1970s and '80s—and shrunk. The company's retail arm closed, and the plant moved out to cheaper Brooklyn in 1991. Schoenholt himself describes it as "the great elastic coffee company" for that reason.

Almost since the beginning, Gillies's customers have been hotels, upscale restaurants, coffee bars and shops whose own names appear on the bags of beans, if any name appears at all. In fact, it's one of the local handful of roasters—Kobrick, Hena and Coffee Holding included—whose product many New Yorkers have consumed without even knowing it. Gilles's

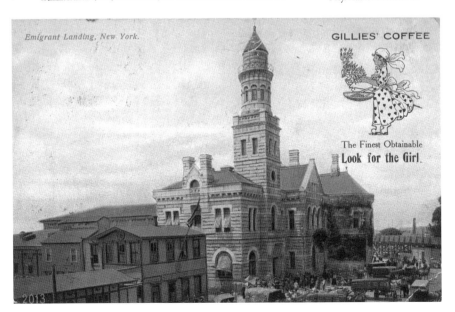

READ WHAT "OLD TIMERS" SAY ABOUT GILLIES PRODUCTS

(See back page)

Established 1840
Still owned entirely
by direct descend-
ants of the founders

GILLIES COFFEE CO.

233-239 WASHINGTON STREET, NEW YORK

Phone BArclay 7-8730

IMPORTERS
WHOLESALERS
ROASTERS

Combination Price List and Order Blank in Effect February 1, 1938

......................................1938

We are large Wholesalers but have a mail
order department devoted to supplying the con-
sumer direct.

SHIP TO

.................................

Check, Money Order or Cash with Purchase
CIRCLE O WHICH IS ENCLOSED

.................................

FRESH ROASTED BULK COFFEES

All Coffees are roasted in our own factory by the most modern electrically propelled machinery,
and are shipped direct from the Roasting Ovens which insures that freshness and delicacy of aroma so
well-known in Gillies Coffees.

Coffees are shipped either in the BEAN or GROUND — if desired GROUND, STATE HOW:
No. 1—Medium for coffee made in old-fashioned coffee pot. No. 2—Medium Fine for percolator use.
No. 3—Extra Fine for Drip Pot, or Silex No. 4—Pulverized.

☞ — Circle O around the way you wish the coffee ground No. 1, 2, 3, 4

Coffee will be shipped in Bean, unless grind is specified.

No. of lbs.
Wanted

$ cts.

.... DINNER BLENDSpecial for February 25
.... ARECO COFFEE, sweet and mild20
.... BROKEN COFFEE, an excellent blend, very special, small and few
 broken beans of better grades26
.... HOTEL BLEND COFFEE, served in leading hotels, a rich blend28
.... MOUNTAIN GROWN BOGOTA27
.... MARACAIBO—the finest of its kind—aged in Venezuela30
.... IDEAL COFFEE, heavy and satisfying33
.... MEDELLIN BOGOTA, delicious, the finest that Columbia produces .30
.... OLD TIME FAVORITE, Medium Heavy32
.... AFTER DINNER COFFEE, very rich38
.... ORIENTAL COFFEE, A Blend of finest Coffees with Genuine Arabian Mocha 40
.... PERFECTION BLEND—enuf said. The finest money can buy39
.... GENUINE JAVA from Sumatra41
.... GENUINE MOCHA from Arabia41
.... French Roasted Coffee26
.... French Roasted Coffee28
.... French Roasted Coffee34
.... COMBINATION No. 1 ground (Coffee, Cereal & Chicory)18
.... COMBINATION No. 2 ground (Coffee, Cereal & Chicory)17

PACKING AND DELIVERY

All our Coffees are securely packed. The 5, 10, 15 and
20 lb. lots are packed in a strong paper bag, tightly re-
wrapped in paper and enclosed in a burlap bag. The 25,
50 and 50 lb. lots are packed in a Wooden Drum. (except
Areco and Combinations.)

FREE DELIVERY within 3rd Parcel Post Zone
(approximately 300 miles)

Beyond this free delivery point we pay one-half (½)
delivery charges. Other one-half (½) must be added to
cost of merchandise.

Amount carried forward

We guarantee the safe delivery of every order and will cheerfully refund your money for anything not found entirely satisfactory.

Left: A price list and order form for Gillies Coffee Co. from 1938. *Courtesy Donald N. Schoenholt.*

Below: An early Gillies Coffee advertisement, with the Gillies "girl" logo printed onto a postcard from the Emigrant Landing in New York City. *Author's collection.*

Emigrant Landing, New York.

GILLIES' COFFEE

The Finest Obtainable
Look for the Girl.

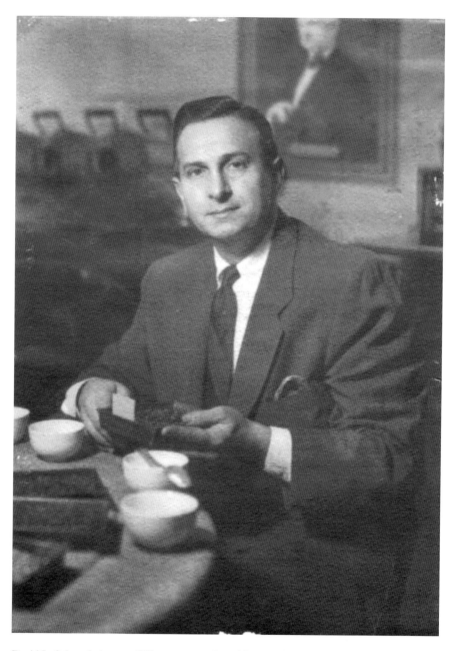

David L. Schoenholt, past Gillies owner and president, and Donald's father, 1952. *Courtesy of Donald N. Schoenholt.*

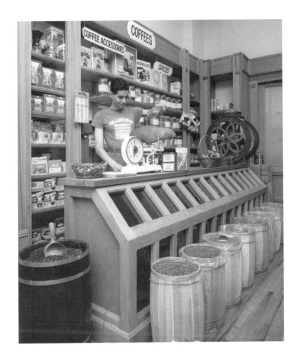

An interior shot of one of Gillies Coffee's retail locations, in 1981. *Courtesy of Donald N. Schoenholt.*

endurance is due, as all natural selection is, to an ability to adapt. In the 1970s, when *gourmet* was the word of the moment, Gillies led the charge into a flavored new world of amaretto and butter rum beans. In the 1990s, when *specialty* replaced gourmet, Brooklyn became the eastern front in the war against Robustas and instant coffee thanks in large part to Schoenholt's personal crusade against bad beans.

Today, Schoenholt doesn't seem too worried about the new roasters sprouting up all over town; in fact, he is almost defiantly confident in what he does. After all, Gillies has survived this long. "Having competition never bothered me," he says, looking over his glasses with a half-playful, half-serious cocked eyebrow. "Having competition is what makes you better."[63]

In many ways, coffee roasting still is a nineteenth-century occupation, like being a blacksmith. It's hot, dirty, loud, lonely work that requires patience, attention, fast reflexes and a healthy blend of fear and respect for fire. Even though coffee itself has been around for centuries, the industrial age of the mid- to late 1800s was really the dawning of the coffee era, when modern technology arguably democratized the trade.

Before the mid-1800s, enjoying coffee in New York meant meeting several hard-to-achieve requirements (and considering some of these bullet points, "enjoy" is probably a relatively loose term). If you were

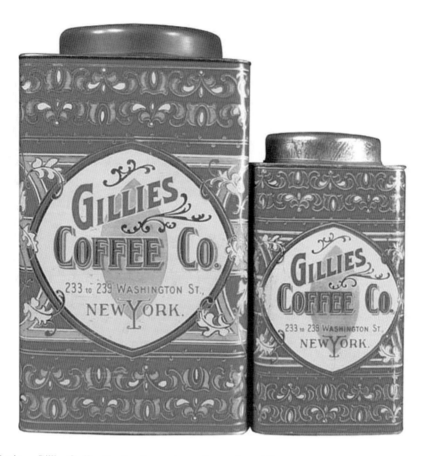

Antique Gillies Coffee Co. tins for storing coffee and tea. The company's early address in Manhattan is printed on the cans. *Courtesy of Donald N. Schoenholt.*

to drink coffee at home, first you needed access to green beans, because commercial roasting for retail didn't widely exist until the late 1860s.[64] Therefore, having access to green beans meant both knowing a merchant who sold them in bulk *and* having the money to afford them, as well as the means to turn them into something useable for brewing. Roasting coffee at home was a primitive affair at best, smoking and scorching it unevenly on the stove. Then the grinding and the brewing and the cleaning up—who wanted to bother?

To drink coffee out on the town, on the other hand, required being male or having a chaperone or male companion (coffeehouses, pubs and restaurants discouraged or flat-out forbade single female patrons), first and foremost.

Then one had to have the spending money and not be particularly bothered by poorly roasted beans badly extracted with unclean or tepid water (or brewed repeatedly, to cut costs).

Home roasters had it positively primitive, but early commercial coffee roasters didn't have it much better: Roasting machines were clunky, heavy and dangerous, heated by coal, exposed to fire and prone to bursting into flame. To make matters worse, the roasting man could not see what was happening to the beans inside, putting him and his coffee at the mercy of his relatively unreliable senses of smell and urgency.

The man who would change all that was a New Yorker by way of the United Kingdom, called Jabez (JAY-bez) Burns, the grandfather of modern coffee roasting. (He shared a name with a Baptist preacher uncle famous for his teetotaling sermons back in London; this fact will explain your later Google and eBay search results.) Burns's invention and 1864 patent for an improved coffee roasting machine included the addition of a helical flange—imagine the paddles that agitate and rotate clothes in a washing machine—that kept the beans in perpetual motion instead of allowing them to sit and scorch over the heat.[65] Burns's improved roasters also allowed the man in charge to remove and inspect a small sample of the beans throughout the process without discharging the whole batch from the heat source, as was previously done. This brought an added dimension to the craft, as sight, smell and even the physical sensation of the hot vapor rising off the roasting beans could contribute to the roaster's decisions and technique throughout the process.[66]

A diagram from Jabez Burns's 1864 patent for the helical-flange roaster, the first modern coffee roasting machine. *U.S. Patent Office.*

Burns also changed the way roasters thought about flavor development in coffee roasting, both through the use of his equipment and through his long experience in the field. He'd been roasting coffee for twenty years before he took out his game-changing patent and loved coffee with an unabashed fervor.[67] Burns was an advocate of charging beans with higher heat, in the beginning and again toward the end of the roast. By reducing the roast time, his designs also reduced the tendency to create baked, boring flavors in the finished brew.

Perhaps most importantly of all—and what cements him as a true New Yorker, in my mind—is the fact that Jabez Burns was never content with having made an improvement and inexhaustibly sought ways to advance even his own designs and theories. He was deeply committed to coffee as an art *and* a science and spent the rest of his life and career exploring and sharing new techniques and information with other tradesmen. "You do not give to pepper or ginger or cinnamon or cloves strength or quality, pungency, or aroma," he wrote in an 1879 edition of the *Spice Mill*, the seminal trade publication he founded, "but coffee you develop and by skill and judgment change from caterpillar to butterfly. You bring out the hidden treasure."[68] That passion carried on as subsequent generations of coffee-obsessed Burns men and their associates continued innovating the technology for which Jabez is remembered, under the mark of Jabez Burns & Sons. The company was awarded numerous patents for coffee coolers, mixers and grinding mills, as well as nut grinders and other manufactory devices, and for most of the twentieth century, it was the standard-bearer

"Clean Out Weekly," instructions on an antique Jabez Burns & Sons sample roaster. *Photo by the author.*

for various commercial industrial machinery. The Burns company and name was acquired by German roaster manufacturer Probat in the late 1990s, and their combined force has proven that two great tastes really can taste great together.

"Coffee is very modern, it's very sexy to talk about," says Karl Schmidt, former president of Probat Burns Inc. "What happens during the roasting process, the various compounds we're creating, the many compounds we know and have identified….Coffee is very special. It's more complicated than cocoa. It's

Detail of the logo on the roasting barrel of a Jabez Burns & Sons sample roaster. *Photo by the author.*

certainly more complicated than wine or beer."[69] Even the earliest commercial roasters understood this much, as widespread large-scale commercial roasting didn't take off in the United States until Burns's machines became available and his philosophies of coffee preparation were published near and far. To the man himself, however, the answer remained as simple as could be: "Tell us what you want to do," reads a 1917 Jabez Burns advertisement, "and we'll see that you get the right machine to do it."[70]

While most coffee roasters seek out the right machine for the job, however, at least one of New York's most storied coffee men came to it the other way around, which changed everything in his life—from soup to Chock Full o'Nuts.

On a wing and a startup budget of $250—not very much money even in 1926—a teenager from the Bushwick section of Brooklyn named Bill Black took out a lease on a subterranean Times Square space so small it's hard to imagine it could contain his outsize personality, let alone the shop he set up there.[71] With a small in-store roasting machine, he prepared, packaged and sold mixed nuts to theatergoers in the neighborhood, and to everybody's surprise, the nuts—and Black himself—were a hit. He quickly outgrew the tiny spot and expanded his retail venture by opening small Chock Full o'Nuts stores all over the city. By 1931, there were eighteen locations, with more planned—proof that Gotham was nuts for nuts in perhaps both senses of the word. When the Depression struck, however, luxury items (such as, presumably, roasted nuts) were in trouble, and in 1931, Black changed products, dumping sacks of green coffee in his roasting machine instead of cashews. He kept the name but focused on selling "something I thought was a necessity—a sandwich (cream cheese and walnuts on raisin bread) and a cup of coffee, for 5 cents each."[72] The shops were all turned into quick-service lunch counters that became instantaneously popular, and Black became a kind of local *knacker* who would pop by to tease the staff and clientele.

The coffee itself was so celebrated that it commanded its own loyal customer base. Patrons asked so regularly to buy coffee beans to bring home that in 1953, after already more than a quarter century of coffee roasting for the luncheonettes, Chock Full o'Nuts finally released its first retail coffee packages.[73] Thanks, too, to the company's astounding advertising budget, within a year, demand was so high that the company established a huge Brooklyn facility dedicated to roasting, grinding and packing coffee for nearly twenty hours a day, every day but Sunday.[74]

It wasn't just his bootstrapped success that made Bill Black iconic to the city—it was also his contradictory combination of being both a genuine people-pleaser and telling the world to go pound salt. Customer service

was paramount in the restaurants, and Bill Black genuinely loved people but also stood up for his staff and was firm in his vision of the way this company should run. His hiring practices were unusually progressive for the time, employing a majority of African Americans in the restaurants. Brooklyn Dodgers legend Jackie "No. 42" Robinson retired from baseball to serve as vice president of personnel in the corporate office.[75] Chock Full offered relatively generous time off and bonus benefits, donated unheard-of sums to various local medical charities and barred customers from leaving tips, a controversial stance Black wrestled with several times through the 1960s and '70s. "I think tipping is un-American," he said. "I do it of course—you have to. But I feel lousy when I tip, because you're putting the other guy down."[76]

Bill Black also thought it was un-American to falsely advertise—not just by selling bad coffee but by the bad selling of coffee. Like most dyed-in-the-wool New Yorkers, he believed in doing things his way, which included writing most of his company's ad copy and acting as its most outspoken booster. "We sell only one grind," Black told the *New York Times* in 1963, taking a swipe at his competitors' various coffee types, which earned them more shelf space in stores. "Every coffee roaster knows there's no need for three. And we call it all-method, not all-purpose. There's only one purpose—to make coffee."[77] Bill Black was like a walking, talking wink, and for the better part of five decades, the impression he had of himself was just as true when applied to his coffee and when applied to his hometown: "All my thoughts are strong on all matters."[78]

Bill Black died in 1983, not long after winning a long and bloody boardroom battle to retain control over the business he'd started sixty years prior, which had suffered years of mismanagement and loss to competition in times of recession and corporate consolidation.[79] After his death, the company began shuttering the restaurants; in 1999, it was purchased by the Sara Lee Corporation, which has since been swallowed up by a larger multinational corporation, shedding the last vestiges of its Empire City pedigree.[80] As of this writing in 2016, four Chock Full–branded cafés remain in the New York metro area: two each in Brooklyn and Long Island, with a smattering of locations elsewhere. The brand remains strong nationally, though it'd be a stretch to call New Yorkers nuts for Nuts these days—and anyway, the coffee is roasted in Suffolk, Virginia.

Despite the democratization of coffee-roasting equipment—thanks in part to Burns's innovations to the technology—until the mid-twentieth century, the vast majority of the coffee consumed in New York was roasted

Dear Madam:

We are introducing what we honestly believe to be the ultimate in instant coffee. Our product is packed in a vacuum can, as good coffee should be, to protect its flavor and aroma.

We won't kid you -- we do not claim that our new instant coffee is as good as our regular coffee, even though it is made from the world's finest, most expensive coffee beans.

But, if you're too busy to brew regular coffee, this is the closest thing to freshly brewed coffee that can be made with the scientific knowledge now in existence.

As an introduction to your first can of New Instant Chock full o' Nuts Coffee, we have arranged for you to get 25¢ off the regular price upon presentation of the enclosed coupon-check to your grocer or super-market.

Please take advantage of this offer. You won't be sorry.

Cordially yours,

Wm. Black, Pres.

425 Lexington Ave.
New York 17, N. Y.

Lagging sales of vacuum-sealed grounds forced Chock Full o'Nuts founder William Black to reluctantly introduce an instant-coffee product to the market. His personal distaste for instant coffee—and his propensity to write the company's ad copy—inspired this clever campaign, which enclosed twenty-five-cent coupons for Chock Full o'Nuts instant coffee along with this cheeky note. *Author's collection.*

Chock full o' Nuts

REG. U.S. PAT. OFF.

No. 212

PAY TO THE ORDER OF _____ **BEARER** _____ $ **0.25**

TWENTY-FIVE CENTS _____ **Dollars**

Valid only when presented to your grocer or supermarket as part payment for one can of Instant Chock full o' Nuts Coffee.

Wm. Black, Pres.

6

The enclosed coupon for twenty-five cents off a can of instant Chock Full o'Nuts Coffee. *Author's collection.*

by a relatively small group of companies, a field dominated by large local institutional roasters like Whechsler Coffee and Greenwich Mills, national brands like Maxwell House and Eight O'Clock Coffee or else by trade roasters like Wolfe & Son and White Coffee, whose knowledge and expertise was utilized by various smaller retail and wholesale outfits throughout the boroughs.[81] In 1935, Ukers wrote, "Compared to other countries the amount of 'retail roasting' in the United States has always been small," though he acknowledged the niche market "for small roasters among retailers catering to foreign-born groups in the United States."[82]

Outside of those niche ethnic segments, the average American coffee drinker was already succumbing to the aggressive marketing tactics and increasingly and alluringly "convenient" innovations made by large, national companies, starting in earnest in the 1940s. Vacuum-sealed packaging gave the perception of prolonged freshness in an era where the refrigerator was all the rage, while premium offers allowed coffee consumers (primarily and statistically the stereotypical housewife) to cash in proof-of-purchase coupons for dishware and small appliances. At the same time, soldiers returning from World War II with an acquired taste for the instant coffee they received in their ration kits changed the face of the American coffee market dramatically, as regionality was trumped by convenience and advertising exposure. "By the 1950s, the five largest roasters in the United States roasted over one-third of all coffee and held 78 percent of all stocks," wrote Steven Topik, coffee obsessive and University of California–Irvine history professor. "By the 1990s, three companies were responsible for 80 percent of the U.S. coffee market."[83]

In New York, this change was felt by most of the regional houses, which by midcentury were finding themselves increasingly undercut by national brands and priced out of their facilities. Longtime Manhattan roasters like Gillies and Kobrick moved operations off the island, while others closed altogether—firms scattered from the Coffee District like rabbits running from a forest fire. In an effort to cut costs, many companies whose roasting had been handled by trade houses invested in their own equipment in an effort to cut overhead. Competition became—and remains—fierce, especially for the institutional and back-of-house roasters, whose primary mission in the business, to a certain extent, was to remain mostly invisible. Roasting, preparing and packaging products under a generic or a private label, the local midsize family-run companies like Dallis Bros., Gillies and Kobrick have found themselves losing out to the more fashionable, buzzy or recognizable brands.

In 1984, amid the chaotic period that saw the breaking up of the old downtown firms and the migration of the coffee business out into the boroughs, Oren Bloostein's life took the kind of twist that becomes the plot of a gee-whiz Broadway musical: "Saks Fifth Avenue salesman trades shoes for brews, opening a coffee store on Manhattan's Upper East Side and selling only the finest 'gourmet' beans to discerning New Yorkers." Hilarity ensues—right?

Bloostein left Saks in 1984 with a dream to bring freshly roasted, extremely high-quality coffee to the city, and in 1986, he opened the first of what would eventually become a ten-shop operation called Oren's Daily Roast. Hilarity, however, didn't actually ensue—not at first, anyway. In fact, in the first few years of business, Bloostein worked himself sick with "bleeding ulcers," and the former department store clerk found it was a pretty steep learning curve to go from moccasins to mocha java. He says he founded the company with a literal interpretation of the name, which has remained true over the past thirty-odd years of business. "When we opened, we were the only ones doing what we were doing, including roasting in the store," he says. "All the other coffee stores sold someone else's coffee. We just had straight coffees, our house blend was blended for people in the store. When I explained it to one man who came in, he shook his head and said, 'Only in New York.'"[84]

Commonplace in coffee-obsessed towns like Seattle, bean stores were a relative rarity in Gotham—especially north of the Village. At the same time, a place selling primarily whole-bean coffee blended to order was a novelty that an enormous and diverse market like New York City could surely support—like the rice pudding restaurant and the peanut butter store (both real places). Before Bloostein left Saks, specialty bean shops like McNulty's in the West Village, the Sensuous Bean on the Upper West Side, Porto Rico Importing Company in the Village and Empire Coffee and Tea on Ninth Avenue in Hell's Kitchen were caffeinating their neighborhood enclaves. Unlike the caffeinated wave that would eventually crash into the city, Oren's Daily Roast didn't even focus on coffee drinks at first. Beverages were a kind of afterthought, added to allow customers to try beans before buying them, and Bloostein expanded his offerings as a means of staying competitive when the market started leaning toward lattes in the '90s. Even today, Bloostein says, "I still consider us a bean store that sells beverage, even though the stores sell way more beverage than anything else."[85]

Like the city itself, in the early days of the business, Bloostein never really slept. He would roast in the middle of the night to keep the store stocked, nap in the afternoon and wake up to work the retail counter or drive to

Brooklyn and attempt to fit half a dozen sacks of coffee in his Jeep. By the late 1980s, however, the company had grown enough to move its roasting facility to Jersey City ("Did Donald tell you I'm really a New Jersey roaster? He loves to say that.") and hire staff to help run the expanding operations. Today, one of those staff members is Bloostein's son Andrew, who learned the craft of roasting from his father and plans to continue the great Gotham tradition of multigenerational coffee businesses.

One of the other things that makes Oren's Daily Roast undeniably "only in New York" is the fact that, like the eight million people who live within the greater city limits, every coffee on offer there has its own unique character profile that can either stand alone or blend in as needed. An inability (or at least a lack of interest) to keep secrets is another quality Bloostein shares with his fellow locals: "I'm fine telling people what's in the coffee. There are no secret blends. The best anybody could ever do was replicate what we were doing, nobody could do any better," he says with a shrug. "We were buying terrific beans, and roasting in a way that other people weren't roasting, and we were roasting every day, so people were getting a freshness that they normally weren't able to get, and our prices were quite reasonable. If you're taking all that into account, I figured the best anybody could ever do was match us, if that."[86]

Oren Bloostein opened his first Oren's Daily Roast location in 1986 on First Avenue. *Courtesy of Oren and Andrew Bloostein.*

Oren's Daily Roast shares the same challenges most independent businesses in NYC face. The first time Bloostein had to close down a store it was due to a nearly fourfold rent increase, and new cafés opening on every block vie for the beverage business that Oren's has had to grow in order to keep bean sales afloat. The pace of modern life has made it harder to sell beans to customers who increasingly disbelieve that they have time to prepare and drink coffee at home; since entering the local market in the 1990s, Starbucks has transformed the city's café culture into a kind of haute fast food, encouraging the no-time-to-brew mentality.

In the 2000s, the meteoric rise of hyper-specialty coffee ushered in by nonlocal companies making New York their second home has pushed the Bloosteins to look for new ways to stand out—not that Oren has anything against what he calls the "cool" roasters any more than he holds anything against the old-timers or the mid-90s espresso bars that tried but failed to capitalize on Starbucks' popularity, many of which have since shuttered. ("This is a very friendly industry," he says with a smirk. "As much as I'd like for some people to get a very severe rash, for the most part, it's very friendly.") Meanwhile, son Andrew recognizes that part of the company's future is in expanding its wholesale reach and in capturing beverage sales at the street level while also maintaining the integrity of the bean store's thirty-year legacy—which is practically ancient in today's terms, as market pressures see independent shops come and go in a New York minute.

"I don't even know how to describe it, except overall it's been fun," Oren says. "It's been a lot of work, but I don't mind doing the work. It's way better than managing the shoe department, let me tell you. When I used to walk, trudging, at like 1:30 in the morning, and I was dead exhausted and I could barely open my eyes, all I had to do was think about ladies' shoes, and I would just smile, and just be so happy to be doing what I was doing. I don't regret it at all."[87]

Despite New Yorkers' typical stubborn insistence on doing things their own way, Bloostein's business remained something of a local anomaly for many years. For some reason, the city was somewhat slow to catch on to the small-batch roasted-locally trend that flourished in Seattle, San Francisco and even Boston and Philadelphia. Zoning and pollution laws, as well as astronomical rents, kept roasters out of Manhattan, and the outer boroughs' caffeine scene was dominated by companies big enough to survive on wholesale alone, without relying on foot traffic. As a result, before the early to mid-2000s, the phrase "New York coffee" mostly brought to mind

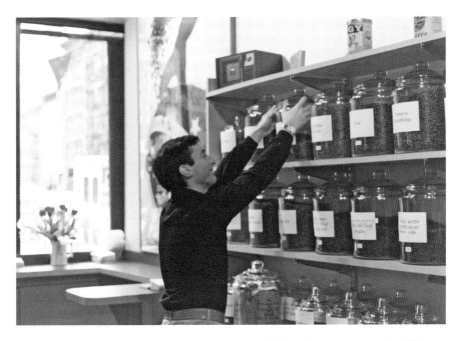

Oren's Daily Roast owner Oren Bloostein, at work at his First Avenue store in the 1980s. *Courtesy of Oren and Andrew Bloostein.*

anonymous stewed brews from diners and Midtown doughnut carts, not single-origin beans roasted by artisans.

Brooklyn itself arguably changed all that. Cheaper than Manhattan but within easy commuting distance, with the kind of reputation for cool edginess that comes with gentrification (a socioeconomic Pandora's Box that I'll leave for a more in-depth book to analyze), the borough began to draw hordes of the young artists and entrepreneurs increasingly being priced out of Manhattan. Neighborhoods that were once ethnic enclaves (Williamsburg), industrial no-man's lands (Bushwick, Gowanus) or waterfront wastelands (Red Hook) were suddenly punctuated by boutique stores, juice bars, concert venues—and, of course, lots of coffee.

While specialty cafés have their own place in the overhaul of Brooklyn (and we'll get to that in the next chapter), it's really the rise of the small coffee roasters there that changed the image conjured by "New York coffee" lately. Though there are dozens of pioneering Brooklyn roasters worthy of inclusion in these pages, for the sake of brevity we'll focus on two companies who have led the charge (that's a roasting pun, by the way): Park Slope's Gorilla Coffee and Red Hook's Pulley Collective.

Everything about Gorilla Coffee has lived up to its name since the moment the roaster-retailer opened in 2002: its deep brews made from beans that could stand up to a more aggressive roasting style; a boldly minimal red-and-black color scheme; and a staff of no-nonsense baristas so effortlessly cool that the café has always felt as much like a club as like a coffee shop. Basically, Gorilla *defined* Brooklyn attitude, and it became one of the first truly neighborhood companies to practically inspire a lifestyle around coffee. (Note: While another small roaster-retail company in the neighborhood, Ozzie's Coffee, had an established local following for its house-roasted beans since 1994, Gorilla was arguably the first "coffee destination" in the borough and even compelled Manhattanites to cross the river for a bag or a brew.)

Founder and former tech design firm manager Darleen Scherer opened Gorilla Coffee in 2002 on a corner in a tree-lined residential Brooklyn neighborhood known for its abundance of baby strollers and freelance writers—basically the most classic ex-Manhattan demographic imaginable at the time. The café's simple menu was built around coffee that was roasted in the middle of the shop on a small cherry-red Diedrich machine, which competed with the buzzing guitars cranking through the speakers overhead.[88] Though Oren Bloostein had started out roasting on a small shop machine years earlier, his Daily Roast was classical music to Gorilla's rock 'n' roll; the two may as well have been on separate planets, not just different boroughs.

Coffee roasting was a complete life-changing decision for Scherer, as it was for Bloostein. Laid off from her tech-based job, she sought something more tangible than the abstract world of the Internet. "I wanted to make something with my hands. I wanted something that has a value. It was kind of this lemonade-stand idea. I'll make something, and you'll give me two dollars. And then we'll just have a lot of people who think, 'That's great lemonade!' and give me two dollars," she says. "I thought, people will like seeing it there, see us roasting it and then putting it behind the bar, so it's fresh. It just worked."[89]

Gorilla Coffee's iconic packaging. *Courtesy of Darleen Scherer.*

Gorilla practically instantly became a local favorite, with literal lines out the door. Within five years, the spot was iconic enough to be immortalized on a cheeky *New Yorker* cover on February 5, 2007.[90] Not a bad lemonade stand. "I didn't really know

Darleen Scherer making a delivery to the Gorilla Coffee café and roastery in the business's earlier days. She and former co-owner Carol McLaughlin were recognizable in the neighborhood for their matching Gorilla-red Vespa scooters. *Courtesy of Darleen Scherer.*

what to expect. I was like, I hope it works. And it was just busy from the beginning," Scherer says. "It was something that just hit a nerve there. It totally felt like part of that community. I loved going there every day. I made so many friends. Once you open something, it just sort of starts to organically take shape. Or it doesn't at all, and then you're out of business."[91]

Remarkably, Gorilla Coffee is now considered something of the old guard of 2000s companies and has long outgrown its shop roaster. The company now has a full roasting and packaging facility in a nearby neighborhood and a second café location basically around the corner from the original in 2013. The brand and store design is so recognizable as a Brooklyn archetype that the company has expanded to Japan—the only place in the world that considers Brooklyn as cool as Brooklyn itself does.

While the attitude has remained the same at Gorilla, the ownership and leadership has changed. In 2015, Scherer sold her shares to her former partner Carol McLaughlin, stepping away from the company she founded. Scherer has since founded Supercrown Coffee Roasters in Bushwick, where she hopes to explore more coffee varieties and a lightened-up roast profile. McLaughlin is still with Gorilla.

The startup and success of Gorilla Coffee ushered in a new era of small specialty roasters in Brooklyn, including Oslo Coffee Roasters, one of the first to focus on lighter-roasted Scandinavian-style coffee, and Café Grumpy, which evolved from its coffee shop roots into an established and expanding roaster-retailer. (We'll get to know it better in the next chapter.) On the momentum of this trend, several multi-roaster cafés in the boroughs have made the transition to roasting their own, including Sweetleaf Coffee, with locations in Long Island City, Queens, and in Greenpoint, Brooklyn; and Variety Coffee in Williamsburg. A handful of Manhattan-based cafés have also taken their roasting to the boroughs: Birch Coffee roasts in Long Island City as well and East Village nanoshop Abraço Espresso has its facility in Greenpoint.

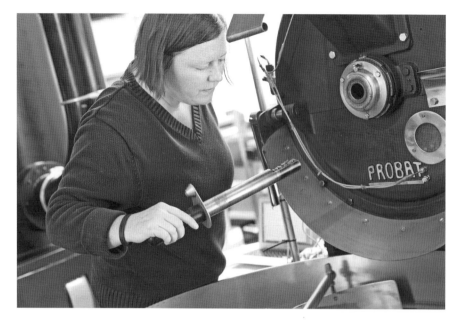

Gorilla Coffee founder Darleen Scherer, standing beside the Probat roaster at her current company, Supercrown Coffee in Bushwick, Brooklyn. *Courtesy of Darleen Scherer.*

For most of these brands, there was a significant appeal to establishing their reputations as retailers before getting into the roasting game, building their customer base and learning the ropes a bit, often by looking over their roasters' shoulders or learning how to cup alongside them. In fact, for most independent coffee-retail companies, roasting seemed unattainable both financially and geographically until 2013, when a truly game-changing development fired up in Brooklyn's Red Hook section: Pulley Collective, a modern re-envisioned take on the trade- and toll-roasting model, which used to dominate the market. Instead of hiring an outside company to do the work of roasting, however, Pulley provides the machines, which are rented by various coffee businesses around the New York metro area. Coffee companies provide their own roasting personnel and roast and package their own products in a shared space.

While it's not a cooperative (Pulley is privately owned, despite the use of the term "membership" for various pricing and scheduling levels), there is a very intentional sense of community fostered by founder and CEO Steve Mierisch, whose family has farmed coffee in Nicaragua since the early 1900s and who himself has been in the specialty industry for years, including a long tenure with Chicago's Intelligentsia Coffee.[92] "It's meant to nurture people,"

Mierisch told the magazine *Edible Brooklyn* shortly after Pulley opened. "I'd like to create a venue where coffee professionals from anywhere in the world can give a class here and invite the local community to come. It'll be more of a venue than a school."[93] Participating roasters can hire the space and the equipment by the hour or by the half hour, buy green coffee through their usual channels and have the pallets delivered straight to Pulley's door. The collective also has a small selection of green coffee available for purchase. The roasters might swap stories or techniques as they come and go through their allotted times, and roasting and sourcing classes create a true feeling of the tide rising, floating everybody's boat.

Shared manufactories are nothing new in the city—one of the first on record was a bakery in Brownsville, Brooklyn, founded by the Workmen's Circle in 1918 and supported by a fleet of ten trucks and two stores.[94] Most such ventures eventually crumbled like so much stale bread, however, as New Yorkers' competitive nature kicked in, and production became fragmented and (stubbornly, one might say) independent. Pulley Collective has managed to avoid the splintering and bickering, however—perhaps because, as Oren Bloostein put it, the industry is, overall, generally pretty friendly. (Even if one does occasionally wish one's competitor would develop a rash.) That spirit is spreading outside of the city, as well. Pulley has also opened a West Coast location, and there are other smaller shared roasting spaces popping up in and around Gotham, with more to follow.

What the future holds for the New York roasters is yet to be seen. While more small local roasters and café-to-roaster operations find their feet in the expanding market for craft coffee, some of the vanguard companies are feeling edged out by a brand-conscious consumer base that seems drawn to name, reputation and marketing—things many of the older roasters have purposely avoided until now, as part of their in-the-background models.

"I think all of the New York coffee roasters who were putting out a quality product were blindsided and not really mindful of the power of branding. We have been back-of-the-house companies and very much punished by that," says Steven Kobrick. "A lot of the well-known companies right now, they started as roaster-retailers. Many of them started as *just* retailers, created a brand for themselves and then bought a shop roaster, and they started to roast their own product. They created brand-product awareness, and consumers flocked to these places."[95]

Kobrick—like Scott Tauber at Hena and Donald Schoenholt at Gillies—faces growing pains his father and grandfather could not have foreseen. "In order to be relevant and in order to create a future for the generations to come, that

Multiple generations of Kobrick coffee men (*left to right*): Sam, Lee, Frank and Sonny Kobrick. *Courtesy of Kobrick Coffee Company.*

we have to break out of the back of the house. That's what it means," he says. "It means that we need to create a brand awareness for our company's history and the values that our company represents, which has always been focused on quality and always been focused on craft."[96]

One of the most obvious ways to achieve that break-out status and get product in front of more eyes (or at least in more mugs) is by entering the realm of the coffee shop, a competitive arena that has made and dashed countless Big Apple dreams since the city's establishment. Whether the shifting market and industry trends will continue to blur the lines between roaster and retailer is yet to be seen, but it's certainly true that the nineteenth-century business of roasting has been left somewhat in the dust of the very modern twenty-first-century café culture it supports. In the following chapter, we'll explore how the New York coffee shop evolved and how it continues to be the metric by which other aspects of the coffee industry's "cool" status is measured.

3
CAFÉ SOCIETY

Coffee Shop Culture from the Colonies to the Contemporary

In many ways, coffee shops have made New York what it is, more or less since the city itself was founded. More than the subway, more than the Yankees, even more than the bagels and the pizza, coffee shops *define* the city in a fundamentally real, cultural way.

No, wait, hear me out.

When you think of New York, what comes to mind? Revolution, innovation, energy, attitude, gumption. The crush of people constantly on the streets—the feeling of being alone in a crowd. The artists and writers who have defined entire generations and the political and social movements that have both torn the city apart and stitched it back together. You think of how expensive it is but also how people manage to squeak by on a few dollars a day. Big business, small business, family business—open all the time, open a limited time or seemingly never open at all. Dark and bitter or light and sweet.

It's all there—in the coffee shop.

New Yorkers didn't invent the coffee shop, but they have gone to great lengths to improve it over time. The earliest Gotham versions, like those of Europe and even back to the sixteenth-century Middle East, were as much meetinghouses, courtrooms and ad hoc financial markets as they were places to get caffeinated. The first such spot on local record, the King's Arms (1696), was essentially an English clubhouse, complete with curtained booths and a second floor used for private meetings and public court proceedings. Witch trials (!) were even reportedly held upstairs (though

no convictions are recorded).[97] The King's Arms found itself down and out when sentiments turned against British rule in the mid-1700s, and favor shifted to the Exchange Coffee House (1732), appropriately named since that's largely what coffeehouses had become: a kind of public office for merchants and businessmen who posted notices about shipments and markets and conducted much of the day's work over strong brews (coffee or otherwise).[98] The Merchants Coffee House, possibly the most significant and most famous of the era, opened around the same time (1737) at Wall and Water Streets, quickly becoming the focal point for local political action and excitement. It was the main gathering place for the Sons of Liberty and the site of some of the most vocal support for the creation of a Continental Congress. Later, when the British occupied Manhattan during the Revolutionary War, captured American ships were auctioned there.[99] Much like Boston's famous Green Dragon, the coffeehouses of New York were incubators for the fight for American independence. Political fervor ignited over mugs of various dark beverages both hot and…well, not *cold*, per se, but probably close to room temperature. Once independence was won, various organizations and unions continued to kindle in the coffeehouses. Regular meetings at the Merchants included groups such as the New York State Chamber of Commerce, the Whig Society, the Society for the Relief of Distressed Debtors, the Black Friars and Freemasons, holding court for hours and voting on bylaws from the booths (even in the days before free Wi-Fi).[100] When the Merchants burned down in 1804, the cultural, financial and political energy of the city simply moved down the street to the French-inspired Tontine Coffee House (1792), which rather famously operated on the membership basis that would inspired the Stock Exchange: shareholders paid dues for the privilege of access to financial books, sleeping quarters upstairs, meal service and lively eavesdropping.[101]

The coffee was an afterthought at these spots and understandably so. It wasn't very good (for reasons established in the previous chapters), and there were plenty of other, more intoxicating beverages to be had instead. Still, these downtown institutions were deeply important male-dominated spaces where much of Gotham's early politics, business and even many of its social customs were initiated and incorporated into popular culture.

By the 1830s, the coffeehouse had largely vanished from the landscape.[102] Manhattan's upper classes began to abandon public meeting places, and businessmen gravitated toward private clubs (like the Down Town Association) that served the same socio-commercial purposes the old Merchants and Exchange did. At the same time, French-style restaurants became more

popular for food and drink than the English-style establishments. The new dining spots attracted New Yorkers for mealtime service at regular intervals during the day, rather than encouraging the all-day lingering that went on at the coffeehouses, where patrons used the space as combination pub and office. Those early destinations, however—the Merchants, Exchange and Tontine—helped set the tone for future generations of New York cafés that would become the classic "third place": an escape from both home and work that becomes integrated into daily life. The coffeehouse is the pole, and its regular customers are the tether balls, circling and circling until they are drawn back in by some irresistible force.

Though the city's northward expansion thinned the crowds in the coffeehouses, the middle classes' upward mobilization and wide-scale industrialization in the mid- to late 1800s turned New York into a city of round-the-clock eaters and drinkers. Workers snatched a bite and a guzzle whenever they could, preferably as quickly and as cheaply as possible. By 1835, the population of the city had swelled to nearly eight times what had been recorded in 1790, with 270,000 people crammed in an area still barely settled north of Fourteenth Street.[103] Folks who could afford to relocate pushed up into less dense residential areas still being developed, which meant the average commute to work got considerably longer by foot or carriage, making it impossible to stop home for what was then called dinner—the midday meal that was traditionally the largest of the day—shared by the family and followed by a lighter "supper" in the late evening.[104] Simultaneously, booming growth brought more and more workers to the city in search of opportunity; the newcomers crowded into too-small homes and spilled out into resident hotels and boardinghouses, most of which lacked kitchens for individual or family use.[105]

While there were upscale dining rooms (mostly French or French-style) since the early 1800s—such as the famous Delmonico's, one of the longest-standing "haute" restaurants in town, opened first as a café and bakery by Swiss brothers in 1825—most of the high-class spots and hotels were off-limits to the working classes, who flocked instead to "Eating-Houses" and the all-night joints that came to dominate the downtown food scene in the mid-nineteenth century.[106] By 1853, roughly half the local population was eating out at least once every single day of the week, with many taking all their meals in chop shops or from street vendors.[107] These establishments fueled daytime and late-night industry alike with nickel cups of coffee, as well as cheap plates of pork or roast beef, beans, mutton, sweet and savory pies, oysters and puddings. These

were not designed to be long, lingering meals. Called "sixpenny houses" after the average cost of a plate there, quick-food spots like Sweeney's (arguably the first such place, opened 1836) and the charmingly named Butter-Cake Dick's catered to clientele that was increasingly on the move, rushing to get back to work after taking just long enough of a break to chew and swallow without risking bodily harm.[108] New York newspaperman George "Gaslight" Foster—himself an enthusiastic eater—wrote, "The downtown eating houses are a place where a man seizes a hasty lunch, bolts it and runs off as rapidly as Mr. Brick and the French soldiers ran away from a suppositious Austrian hussar."[109]

Foster, who was in many ways the first to capture in writing what made life in New York so singular, was astounded by the phenomenon of these quick-serve restaurants: "New York could no more exist without her Eating-Houses than you, dear reader, could get along without your stomach," he wrote in the 1850s, marveling not only at the capacity New Yorkers had to eat and run but also the restaurants' ability to satisfy the crushing demand.[110] "Just think of it—two or three thousand people going up and down the same stairs and dining at the same tables, within three hours! Such a scene cannot be imagined by any but a New Yorker."[111]

Aside from the general gastronomic sea change that the eating house inspired, the businesses' use of coffee as a loss leader was instrumental in creating local habits around the beverage—habits that, as we'll learn, die very, very hard. Even when the coffee market was in "a precarious condition," as it was for most of the latter half of the nineteenth century, the consumer cost remained steady and stubbornly capped at a nickel.[112] Despite constant news reports about the huge fluctuations in both the price and availability of green coffee due to wartime, speculation and unexpectedly large Brazilian harvests, New Yorkers demanded a five-cent cup with their lunch of beans, ham sandwich or slice of pie, come what may.[113] (Actually, somewhat incredibly, the average cup of brewed coffee cost five cents for nearly one hundred years. In 1946, the Office of Price Administration authorized increases, but most businesses found that customer pressure kept the price ceiling at a nickel, and so it remained for years afterward.)[114]

Coffee, once an incredibly expensive luxury item, had become fuel for the fires of revolution and, increasingly, industry. As more working men and women turned to the eating houses and coffee-and-cake joints for quick meals on shift breaks, they found their dependence on coffee grew steadily and quickly realized that caffeine kept the gears of commerce turning. Coffee, like bread and water, became something of an unspoken

right of the people, and as such, it needed to be cheap, hot and fast—like the factories themselves.

Perhaps nothing so captures this mechanized and mobilized movement like the Automat. Designed and originated in Germany, an Automat was a kind of vending-machine diner where customers selected food items from enclosed cases, the doors of which would open upon payment of coins in a slot. A doughnut or slice of pie, along with a five-cent coffee doctored with free tableside sugar and milk, became a dime's worth of breakfast, lunch or dinner. New York's first Automat opened in Times Square in 1912, operated by the Philadelphia-based company Horn & Hardart. Its immediate popularity further cemented coffee's place as a cheap punctuation on any meal; in hard financial times—such as the Depression of the 1930s—sometimes that nickel coffee became the meal itself.[115] Quickly, similar cafeteria and diner-style eateries sprang up near offices and bus and train stations, capturing passersby. Within a year, Seventh Avenue below Fourteenth Street had at least two hundreds diners and quick-lunch-style spots, where, "according to one observer, 'soup, roast lamb, potatoes, salad, Greek pudding and bread may be secured for thirty-five or forty cents.'"[116] A cup of coffee would still keep the tab under half a dollar.

While thousands of New Yorkers resigned themselves to dashing in and out of the luncheonettes around town, not everyone was content with the indignation and indigestion this type of cattle-call occasionally resembled. One hungry and dissatisfied customer wrote:

> *A fifteen-cent malted milk with two crackers made a full meal for me in those days, until one day at the soda counter I saw the sticky mass from which the clerk dipped the syrup he put in my concoction. To cap my disgust and revolt me permanently, he stuck his thumb in the egg as he broke it on the edge of the glass from which I was to drink. That was the end of that sort of midday meal. The only alternative for me was one of the quick-lunch places where about two thousand people eat at noontime, with all the unbearable clatter and confusion. I would wait until 2:30, when the place was rather empty, and ordering a piece of toast, sit down for a dreary moment.[117]*

Appalled by the "too-great intimacy with one's fellow man," this unhappy eater wasn't content to simply whine about the situation. A New Yorker through and through, Alice Foote MacDougall picked up, brushed herself off and dove into business for herself instead. In the process, she not only

transformed herself into an icon of the city and a generation, but she also forever changed the way Gotham took its coffee.

Alice Foote MacDougall was practically the definition of spark plug. Barely five feet tall and squat all around, she was like a walking combustion engine in a lacy dress and a Victorian hat. She took no prisoners but certainly did take sides on every issue, sometimes brazenly contradicting logic. MacDougall was born into genteel New York society. Her maternal great-grandfather had been city mayor in the 1820s, and her father made (and subsequently lost) a fortune as a steel broker. The family lived on Washington Square North in the kind of house with a servants'

This showy hat displays a flash of the whimsical side of Alice Foote MacDougall. *Courtesy of Caroline MacDougall.*

entrance and winter windows that fogged with the warmth of a glowing fire. She married and had children young, and her husband was successful in the coffee jobbing, or wholesale, business for the first few years—until he suddenly wasn't anymore; he died a broken and bankrupt man, leaving MacDougall to survive by wits as a single mother. Knowing something of his business as an outside observer, she took the gamble of a lifetime in 1907 and rented a small office for herself on Front Street in the district, establishing herself as the first known female coffee broker (though she kept her gender ambiguous with letterhead reading "A.F. MacDougall").

"I chose coffee because it was a clean and self-respecting business," she wrote in her *Autobiography of a Business Woman*, easily one of the most delightful coffee books written (until now, of course). "No friend, however much he might love me, would buy or drink bad coffee. Therefore I knew I would be free from the stigma of charity."[118] Her first orders came from family and loved ones, but she insisted they only order if they paid and only pay if they liked the product, period. She ground five pounds of coffee at a time by hand and delivered it herself, hauling sacks around town. For the first time in her life, she found herself knocking on the side or back door of homes like those where she had spent her youth.

In a few years' time, she had gained enough of a reputation to begin canning coffee and selling it wholesale; in 1919, she opened her own store, the Little Coffee Shop, in Grand Central Terminal, selling whole beans to travelers passing through—or attempting to, anyway. Sales were desperately slow at first, and after six months, MacDougall's sons begged her to close it. Stubbornly, she refused: "I have a natural antagonism to giving up, once I have started anything," she wrote. "I simply don't believe in failure."[119]

MacDougall struggled through two years of stalled business, facing financial ruin, when the city itself intervened, in a way, by inflicting some torturously unforgiving weather upon the population. "Do you know New York?" MacDougall wrote. "Lovable as a dainty maiden in her Easter dress of smiles and flowers…she becomes a raging demon when the storms of winter assail her."[120] One sloppy, freezing rainy day, MacDougall watched commuters blow in and out of the terminal on gusts of wind, miserably clutching bags and dripping to the skin. Thinking quickly, she struck while the iron was hot—the waffle iron, that is. She asked a maid to run and fetch one from her house, mixed up a batch of batter and placed a hastily written sign in the window, stating simply, "Waffles." The first day, she sold hot, made-to-order waffles for a nickel, with a free cup of coffee; the following day, the coffee was five cents, but the waffle was free.

MacDougall wasn't the first entrepreneur to have the notion of having a two-item limited menu, but she certainly did perfect the art of the gimmick early on. In her 1926 cookbook, *Coffee and Waffles*, she freely admits her inability in the kitchen—"While I had never cooked a meal myself, I taught others to do so," she wrote—and her recipe for waffles doesn't actually include any instructions at all, beyond mixing the batter.[121] (What you do with the batter is your business, apparently.) That one recipe spawned an empire: Alice Foote MacDougall & Sons.

By 1922, the business had expanded to include a second location in Midtown West: a southern-style restaurant with open waffle irons cooking around the clock. "In March, four months after our opening, we served eight thousand people with three full meals a day, and by August 1923 we took on more space, doubling our seating capacity less than a year after opening," she wrote.[122] Frazzled and nerve-wracked from years of struggle and overwhelmed by the stress of success, MacDougall took a trip to Italy to restore her senses. There, she discovered the charm of the coffee bar, the porticos of Venice and the bridges of Florence. Foreshadowing the espresso epiphany that a good Brooklyn boy from Canarsie named Howard Schultz would have in the 1980s, MacDougall came back to the city with caffeinated

Portrait of Alice Foote MacDougall. *Courtesy of Caroline MacDougall.*

The Cortille was MacDougall's courtyard-inspired coffeehouse at 37 West Forty-Third Street in Manhattan. *Alice Foote MacDougall's Cook Book.*

world domination on her mind. She quickly set out to open a string of astoundingly popular coffee shops designed to replicate the experience of the romantic Italian, and later Spanish, outdoor café.

The restaurants were as much a contradiction as MacDougall herself and, indeed, as much as New York as well. The decor was porcelain and blue lace, faux-antique and weathered in an attempt to capture Old World charm; the menus, however, served somewhat mishmash tastes. Her first restaurant, the Cortile, advertised very un-Italian sandwiches of tongue and horseradish and corned beef and pickled relish; the Florentine restaurant Firenze featured "Plats du Jour" of seafood Newburg and a variety of French and Swiss cheeses.

Confused or not, New Yorkers loved it. By the time she revealed her fifth location, the Spanish-tinged Sevillia, her name as a brand and the indoor-outdoor aesthetic of her spaces guaranteed success. Sevillia, reported the *New Yorker*, opened on a Wednesday evening; come Thursday, there was a tremendous wait for a table and a line that didn't quit. That Saturday alone, more than two thousand people "were fed (body and soul)" in the dining room.[123]

MacDougall openly reviled the quick-lunch counter with its grubby service (all those thumbs in the malted milk) and unrefined atmosphere, intentionally created environments that radiated peace and elegance and, by nature of New York in the 1920s, didn't much appeal to men. "Mrs. MacDougall's coffee houses are thronged with her admirers," the *New Yorker* chuckled sarcastically. "They are the paradise of the uptown bridge club, the prosperous Brooklynite, the suburban shopper, the eager sightseer from the hinterland; ladies substantial and ambitious for the better things, whose digestion is aided by a little culture."[124] Perhaps it was the dainty banana-and-mayonnaise sandwiches that put men off the restaurants, but more likely it was that they were arguably designed for women by one of their own.

Until the midtown boom of the early twentieth century, the public food stalls and halls were off-limits to women. The colonial coffeehouses often forbade them outright; the later eating houses with their oyster plates and porky beans were jammed with working men and hardly heard the swish of a petticoat, as it was considered unseemly for women unaccompanied by male escorts to eat in public establishments. Slowly, starting in the 1890s, change began to blossom in the storefronts of the city—inspired less by equal rights for women and more by equal opportunity by vendors, who realized the vast market potential of an underserved population. Ice cream parlors, teahouses and the MacDougall coffee shops captured the female business and the female imagination. Soon enough, lunch counters were co-ed as a matter of course, as more women entered offices as employees, taking their midday meal break like any gent. "It makes food and drink taste better to be served from a beautiful place and an interesting cup," MacDougall wrote, and it also didn't hurt business.[125] While her first year at the Little Coffee Shop saw gross income of $568, by the mid-1920s, the company was drawing upward of $3 million annually.[126] In 1927, MacDougall famously signed a five-year, $1 million lease for the Sevillia at 50 West Fifty-Seventh Street. (That would be more than $13 million in today's dollars.)[127]

Unfortunately, almost all of that would change *tout de suite*. Beauty and coffee alone weren't enough to sustain the operation's high costs through the Great Depression, and total revenue sunk from the many millions to $400,000 by 1931, when the restaurants were put into receivership.[128] Though she fought to regain control over two of the businesses, the stress of failure proved to be too much. After three years' attempt to reclaim her former glory, Alice Foote MacDougall reluctantly retired, and she died in 1945, after a decade's worth of disappointment and increasingly ill health.[129]

While her fortunes came and went, MacDougall's personality was steadfast. She was a true character, a true New Yorker and an absolute individual. What other city could spawn a businesswoman—certainly one of the first of her ilk—who actually advised other women *against* holding careers? She was also an outspoken anti-suffragist who cast her first and possibly only vote in the 1924 presidential election (for Republican Calvin Coolidge, whom she believed would "throw up a needed bulwark against Socialistic aggression").[130] Through it all, MacDougall remained characteristically scrappy and ever a realist who believed in the beautiful, fickle force of prosperity. "Success is an absurd, erratic thing," she wrote. "She arrives when one least expects her and after she has come may depart again almost because of a whim."[131] Though none of the MacDougall

Alice Foote MacDougall is buried in Woodlawn Cemetery in the Bronx. *Photo by the author.*

coffee shops survived the 1930s, there does still seem to be a little bit of her pluck in every successful New York café these days.

While the Great Depression did little for the average American wallet, it was actually something of a boost for the coffee industry, if not in terms of quality, at least in terms of quantity of cups sold. As the clamps came down on spending and unemployment in the city skyrocketed, coffee became more and more important to the masses. For one lousy nickel, anybody could get a cup of something warm to soothe the soul and even load it up with milk and sugar in an attempt to fill the stomach. Prohibition, which predated the recession by a full decade, had already managed to encourage coffee habits. Between 1919 and 1925, the average U.S. citizen was drinking a full two pounds more a year than previously recorded (roughly equivalent to one hundred extra cups per person).[132] As a result, the 1930s and 1940s were a boom time for diners and Automats, where anybody could sit nursing a bargain brew or even bottomless mug, no matter how down one's chips were. Prices on everything else rose, but coffee held fast and cheap; in the process, it also became completely ubiquitous. Adding to the momentum, GIs brought their new addiction to coffee—both the real stuff and the instant crystals every soldier carried with his rations—back home after serving in World War II, making the homefront a much more caffeinated place upon their return.

Before long, coffee was available absolutely everywhere in the city—a truth that still holds, especially in Manhattan. Suddenly, coffee was easier to find on the streets and sidewalks than a public restroom or potable water from a fountain. A doughnut cart equipped with a huge urn parked on every sidewalk; diners and delis up and down the block refilled bottomless mugs and stocked towers of paper to-go cups—there was coffee no matter where one turned. Banks gave away free cups as rewards for opening an account; churches installed huge pumping percolators for get-togethers after services. Later, gas stations began peddling caffeine under the auspice of safety, encouraging drivers to remain alert.

In order to sustain coffee's dominance, two things needed to happen: the coffee itself needed to be cheap, and New Yorkers needed to be satisfied drinking cheap coffee. While it's not necessarily always the case, *cheap*

Who knows how many hundreds of thousands of cups of coffee are ordered from a cart like this every day? *Courtesy of Brett Leveridge.*

is intentionally used here as a reflection of quality as much as price. The average American coffee pot during the late 1940s and into the 1950s was being brewed with low-quality, poorly roasted coffee—typically stale, often of the Robusta type and, of course, badly roasted. In order to keep cost as low as possible (and still eke out a margin), diners, street vendors and restaurants stretched a pound of coffee practically beyond recognition by brewing it weakly or even brewing twice using the same grounds. Convenience and caffeine trumped flavor and quality, a trend that played out across the midcentury culinary landscape, both in New York and elsewhere. TV

dinners replaced home-cooked meals, or families opted for the predictable mediocrity of fast food over a local cook's daily dish. In the course of a single generation, the notion of a coffee shop as "a place of rest and beauty, a little haven to entice the weary commuter" had died an unremarkable death, buried anonymously under the new high-rise residential buildings and indigestion palaces that lined the streets of midtown.[133]

Don't eulogize the coffee shop yet, however—it was weak, but it still had a pulse. All it needed was a little CPR: Clementine Paddleford resuscitation.

It doesn't sound like it should be her real name, but it was, and it suited her. Clementine Paddleford was a New Yorker by way of Kansas, and as plain-looking as her home state, with baby-doll bangs and a vaguely Victorian sartorial sense, but she also had a killing smile—the kind that crooks up on one side as if to ask, "Are you pulling my leg, or am I pulling yours?"—and a personality to match.

Married and divorced within a single whirlwind year at age twenty-five (1923), Paddleford lived the rest of her life single in Manhattan, where she shared an apartment with several cats and a young ward, the orphaned daughter of a late friend. She didn't cook, and when she dined in (which was rare), meals were prepared by a maid. The recipes she printed in her *New York Herald Tribune* columns were tested entirely by newspaper staff. In 1932, surgery to attend to a malignant growth on her larynx also necessitated the partial removal of her vocal cords, which left her voice husky and forced her to breathe through a tube for the rest of her life. This, however, did not impede her exploration of—or enthusiasm for—foods of any and all types.[134]

Adventuresome in taste and a bit purple in prose, Paddleford wrote daily items about food for the *Herald Tribune* and authored, among others, the now largely forgotten 1960 book *How America Eats*. More than that, however, she popularized food writing to an ecstatic degree, encouraging a city of lunch-counter lackeys to exchange tuna salad for tuna tartare and to take a hungry stroll through Manhattan's Chinatown or Little Italy. Though she knew the food of New York best, her explorations weren't limited to the local: "At a time when few people in Philadelphia knew what enchiladas were and few in Chicago knew what cioppino was," according to the *New York Times*, "Ms. Paddleford described them both in loving detail, along with New Orleans–style red beans and rice, Lindy's cheesecake and Hungarian-American stuffed cabbage from Cleveland."[135]

While the majority of New Yorkers were still standing in line at the Automat or squeezing onto a stool at a lunch counter, content with their nickel coffees, Clem Paddleford was out scouring the off-beat restaurants

and exotic neighborhoods for the most delicious flavors she could find—including coffee, which she wrote about often, romantically and exceptionally well. She didn't just write about food, though, she also genuinely loved it. In her column, she almost *made* love to it; her writing was sensual to the point of flirting with absurdity, but her readers (forgive me) ate it up. "Coffee is the Italian espresso, black as an owl's nest at midnight," she wrote in a 1948 piece about an "overlooked Italian restaurant" that she visited on a tip from a reader. "One sip burns your tonsils, two sips shines your shoes."[136] Not only is it spot-on, the description is also stunningly *au courant*—and it wasn't even her first mention of espresso coffee, which was still so relatively unknown outside of Italy that to most New Yorkers it might as well have originated on the moon. In 1945, she was already writing about the "nickel-plated monster lording it over the room" at Dominic Parisi's little six-table café, Caffè Reggio, penning what might be the earliest descriptions of cappuccino recorded in a Gotham newspaper: "Cappucino [*sic*] is a cup of espresso with steam-heated milk floating lazily over the surface, and that delicate bouquet is just the merest pinch of ground cinnamon. And this, according to Mr. Parisi, 'the ladies like very much.'"[137]

In the 1940s, she sought cappuccinos at the Italian shops and cafés in the Village, most famously the aforementioned Reggio on MacDougal Street, as well as its offshoot, the Peacock on West Fourth Street. In the early 1950s, she wrote about the Bohemian renaissance the coffeehouse was enjoying downtown, where young people sipped Viennese coffee with whipped cream or steaming black espresso. Before retiring her post in the early 1960s, she wrote of "coffee, that divine elixir of the gods," which should "be the climax of the perfect little dinner."[138] She didn't mean just a pot of Maxwell House, either: "Serve it with ceremony. Blend your demi-tasse with spice and brandy; serve it in a halo of leaping flames. Present coffee French, Italian, Turkish—coffee with sophistication!"[139] She informed readers where they might buy stovetop moka pots to try to re-create European brews and even where to buy their own coffee trees to grow at home. "Did you ever see a coffee tree?" she asked in a 1961 column. "Then you remember its beauty, the shining leaves, the fragrant white blossoms, the bright red berries, these resulting in the beans which make the popular aromatic beverage."[140]

Clem Paddleford represented, inspired and wrote for those New Yorkers for whom food was more than fuel and coffee more than caffeine. Her columns foreshadowed the movement that swept through Manhattan in the late 1950s and through the '60s, specifically in the West Village and its

Dominic Parisi's treasured espresso machine, on display at Caffè Reggio. *Courtesy of Brett Leveridge.*

neighboring areas. Restaurants began to focus on preserving traditional or regional cuisine or exploring unique flavor experiences; the "old is new again" trend gained traction with a younger generation increasingly interested in the raw energy of the culinary city, which happened to be

contained in somewhat Bohemian pockets below Fourteenth Street or on chic and sophisticated uptown side streets. A cheeky column in the *Times* reported:

> *Already espresso has received a running start in New York. Local-colorists, coin-in-the-fountain secretaries and many foreign visitors here have so taken it to their palates that* Variety, *the actor's gastronomic guide, reports in its headlinese: "Greenwich Village Jumps with Java Espresso Joints." Espresso has traveled uptown to the West and East Side of Manhattan, with a dozen coffeehouses in various guises—some with the gaslit and velvet-walled look of the Cafe Greco near the Spanish Steps in Rome; some with shiny Milanese décor and sandwich menus listing prosciutto and bel paese (or, defiantly, ham and cheese).*[141]

The 1960s saw the first whispers of counter-meets-counterculture: coffeehouses and the odd espresso bar played host to socialites and aesthetes uptown and socialists and artists downtown. Cafés like the Peacock mentioned earlier and the Coffee Mill on West Fifty-Sixth Street ("which features twenty different types of coffee and thirteen teas; has art exhibits on the walls, and employs as waiters and waitresses folks who were or are currently performers in the theater world") may have catered to different clientele, but the customer motivation was similar.[142] More New Yorkers began to seek out food, drink and culture as an experience and *expression* of the city, about as far away from the lunch-counter cup as a person could get at the time. The intentional slowing-down of pace in the coffeehouses was inspired by the European model, especially French, Italian and Viennese cafés, where coffee was as much a social lubricant and artistic catalyst as it was pure stimulant. In Greenwich Village, spoken-word performances and protest music were the mediums of choice; uptown, fine art and literature created a different vibe. In both city spheres, however, meeting for coffee became a symbol of society and solidarity, a way of linking up with other like-minded locals. The café was democratic in price tag and casual in mood; it offered an escape from the grind of daily workaday life. "To rushing city dwellers the new coffee houses provide a haven of repose," wrote Andrés Uribe C. in his seed-to-cup exploration, *Brown Gold.* "Candlelight, music and paintings provide coffee drinkers with a welcome relief from the monotony of urban tensions. Few of the coffee houses are elegant or expensive and the patrons are urged to relax and enjoy themselves over the delicious new coffee drinks."[143]

As New York considers itself the self-appointed center of the cultural universe, it seems like the specialty coffee scene should have bloomed—or at least boomed—here first, but that wasn't the case. Starting in the 1970s, recession, Vietnam War stress and a dramatic drop in coffee quality (thanks to the rise of cheap Robusta) created tension in New York, and as a result, the coffeehouse gave way to the bar as watering hole of choice: the beer and whiskey crowd downtown, wine and martinis uptown.[144] The ubiquity of cheap brewed coffee that appeared on the sidewalks, at every corner store and in bottomless diner mugs from the Bronx to Staten Island turned the drink into more of a basic necessity than a luxury product—like riding the subway. (Even in 2016, there are one-dollar cups to be had at every turn, which makes the idea of paying three or four dollars for a latte a tough sell to many New Yorkers.) Compounded with the rising price of real estate, high labor costs and the enormous potential competition, there wasn't much incentive to capitalize on the growing buzz around "specialty coffee" until the mid- to late 1980s.

The appreciation for fine coffees and an elevated café experience that had gained momentum in the 1960s fizzled in New York by the end of the decade, though it thrived in West Coast cities like Seattle and San Francisco, where good coffee had turned into a full-fledged movement by the mid- to late 1970s. Coffee shops focusing on high-quality and single-origin brewed beverages took off in their caffeinated communities, such as the Pannikin in San Diego and Seattle's Starbucks—originally more of a filter-coffee joint than it is today; Boston's Coffee Connection introduced wine-quality fine coffees to East Coasters starting in 1975.

In the early 1990s, however, the coffee-focused café came back in full force—and with it came a cultural and culinary shift so caffeinated that it's still keeping New Yorkers awake nights. It is almost as though a torch was passed, actually. In 1991, the city's last-remaining Automat on East Forty-Second Street and Third Avenue closed its doors, while all around the city a new type of coffeehouse was brewing. At that time, only a handful of independent outposts and small regional chains focused primarily on coffee, but they could see the new wave coming. Cooper's Coffee and New World Coffee were early adopters of the Seattle-inspired craze, taking the risk on a city population ready for something new and percolating change with their price and offerings. New World Coffee's co-owner Ramin Kamfar told the *New York Times* in 1994, "My partner was talking about opening coffee bars three years ago and everyone said, 'Nah, no New Yorker will stand in line to pay $3 for a cup of coffee they can get for 70 cents at the deli,' he said.

Then we looked at Chicago, where even secretaries were lining up to buy cappuccinos, and decided everyone was wrong."[145]

Everyone *was* wrong, and before long, scores of shopkeepers, construction workers, police officers, students, politicians, buskers and yes, "even secretaries," were happily paying more than twice or three times the going rate of deli coffee for a cup of something special—or at least "specialty."[146] The number of coffee bars in Manhattan went "from a handful to almost 100" in less than two years in the early '90s, even if they were what journalist Corby Kummer described as "'café in a box': the same marble counters with the same cute mile-high tea tray laden with the same dried-out scones…the same overruled and *crema*-less espressos, the same watery brewed coffee, the same aggressively art-directed logos."[147] (Yikes.)

There certainly was a learning curve for the local population, too, not just the cafés themselves. In a 1993 article, the *New York Times* reporting on the arrival of the city's first Starbucks included a pronunciation guide for "latte" ("pronounced LAH-tay"[148]), and Kummer complained that New Yorkers' general skepticism about espresso made it impossible for baristas to pull acceptably short, flavorful shots. ("Everybody complains if we give them a normal amount," he was told by a barista who handed him a too-long pull.)[149] By 1995, however, the trend was in full force: the United States had about seven thousand specialty cafés; in 1999, that number was up to twelve thousand.[150] In New York alone, there were about two hundred in 1996, with Starbucks planning another one hundred within five years.[151] Too-rapid growth caused the bubble to burst for many of the pioneering early '90s espresso bars, as the cafés opened faster than the public could accommodate. Many shuttered due to high rent or were swallowed up by national chains set on widespread local expansion. September 11, 2001, put the lid on the coffee boom temporarily, as New Yorkers shifted focus, businesses closed and the city struggled to find its footing again—but from the tumult there emerged a handful of visionary shops that would come to define an era and kick off a major transformation of New York's coffee scene, so much so that their names almost became a mantra to the caffeine-crazed: Gimme!, Grumpy, Ninth Street and Joe.

"I feel very grateful for when we started. I wouldn't attempt to open a Joe now. If you came to me with that idea, I'd say, 'Are you crazy?' At this point I'd say no *way* would I open a coffee shop. Timing was tremendously important."[152] That's what Jonathan Rubinstein, owner of Joe Coffee Company (formerly Joe the Art of Coffee, a tagline Rubinstein calls "the biggest mistake we ever made") says in 2016—but then again, he also used

The original location of Joe Coffee Company (formerly known as Joe the Art of Coffee) opened on the corner of Waverly Place and Gay Street in the West Village in 2003. *Courtesy of Joe Coffee Company.*

to say he didn't want to own more than five stores.[153] As of this writing, Joe has sixteen locations in New York City and Philadelphia, with five more planned in 2017.

When the first Joe location opened in the West Village in 2003, the boroughs were just starting to buzz about specialty coffee—Jack's Stir Brew opened just a few weeks after and a couple of blocks away from the original location of Joe, and Gorilla (see previous chapter) was already a year old and a cornerstone of its Brooklyn enclave. Oren's had been serving the mid- and uptown crowds for a relative dog's age. But it wasn't until Gimme!, Grumpy, Ninth Street and Joe started to roll off the tongue like John, Paul, George and Ringo that New York really seemed to light up to the caffeinated invasion.

"I remember weekends our first year were bananas because people were reading about us and hearing about us, and they wanted to experience this good coffee—almost like the Momofuku craze or the Magnolia [cupcake] craze or something," Rubinstein says, remembering the lines and the tourists and the celebrities. "They were coming from all over the city, and it was overwhelming."[154]

Owner Jonathan Rubinstein believes that latte art is what put his Joe cafés on the map. *Photo by the author.*

It's true. It *was* overwhelming. (Full disclosure: I know because I was a barista at that first Joe in its early years; I have the steam-wand scars to prove it.)

"We were a latte-slinging place," Rubinstein says, "and certainly the *most* original thing that set us apart was that we were the only place doing latte art, where people used to come with their cameras and stand in front of the espresso machine." Latte art, a technique baristas use to create designs with espresso and steamed milk, he continues, "was being done all over the country at other shops, but in New York, I'm positive that one literally did not exist, we quote-unquote 'invented' it here."[155]

Inspired by the sophisticated upscale style of the Seattle espresso bars and transplanted to a cozy corner on Waverly Place, Joe was one of the forerunners of a rebirth of café culture that got off to a frothy start in the 1990s but really picked up steam in the early 2000s. Joe's focus was on customer service (purporting to employ "the world's nicest baristas") and a latte-slinging menu, and it caught on quick. A second location opened in the company's second year, and a baker's dozen followed suit.

While latte art put Joe on Manhattan's specialty coffee shop radar, Ninth Street Espresso existed in another world—almost literally, in a section of the East Village that may as well have had "Here There Be Dragons" written across it on maps in 2001, when the first NSE shop opened. Even Rubinstein recalls the place with a kind of gauzy awe, the way one might describe the coolest kid in one's high school. "I mean, Ninth Street Espresso was open before we were," he says, "and it was definitely the one place at the time that was *really* thinking about the product."[156]

There's still no coffee shop that epitomizes New York more than Ninth Street Espresso, and owner Ken Nye is a classic, dyed-in-the-wool native, with wild stories of the wilder nights spent tending bar at his pre-NSE joint 9C, which was on the corner near where the original coffee shop still sits.

"The energy of my store in the early days was very organic," he says. "I owned the bar next door; it was a very rough bar. We rolled up our sleeves on a daily basis, and we'd get into it with everybody. It was a very New York

The Joe location on East Thirteenth Street held one of the city's first latte art throwdown competitions: head-to-head contests to see which drink is more artfully crafted. The competition pictured was a fundraiser for relief after natural disaster struck Haiti, and the café was crowded with onlookers, supporters and coffee geeks. *Photo by the author.*

environment. Everything about the way that we existed every day in service was super underground New York. Then I decided to be a genius and come next door and make coffee, because I was a coffee geek. So I brought this very unique energy next door."[157]

If Joe was the *yes* café, known for its warm fuzzies and hospitality, Ninth Street was certainly the *no* shop: no espresso to go, no extra-large lattes, no Splenda, no nonsense. Nye and his staff enforced the shop's policies of purity so much so that they wouldn't hesitate to tell a guest to leave for asking the wrong questions or ordering the wrong coffee. If it recalls a certain *Seinfeld* episode, you're imagining correctly.

"I half say it in pride because it was fun, and I think it set the tone, but I'm also a little bit embarrassed because now I feel very strongly about good service and hospitality, and we were the antithesis to that," Nye says. "We were not hospitable, and we were not very nice. It was this very raw, almost punk-rock thing, like, 'I'm here to do one thing, make really great coffee. If you like it, great. If you don't, fuck off.'"[158]

While Joe and Ninth Street played good cop–bad cop on the island, two shops sprouted from the Brooklyn rubble around the same time: Ithaca roasting company Gimme! Coffee opened a minimal, espresso-obsessed outpost in Williamsburg in 2003; and a dark horse called Café Grumpy started its first multi-roaster shop in 2005 in a relative no-man's land of a neighborhood, arguably becoming the other destination café of the era, along with the remote-for-Manhattan Ninth Street.

"We thought, 'How hard could it be to make great coffee?'" Caroline Bell remembers of the early 2000s, when she and partner and Café Grumpy co-owner Christopher Timbrell would "go out to try different coffee places and be complaining that nothing's that great." Every so often, she says, something would stand out as really special, and the two of them would be thrilled: "I remember I was living in Williamsburg and Gimme! Coffee opened.[159] I was so excited, I immediately called Chris and said, 'Ride your bike over here!

Top: The minimal Ninth Street Espresso logo on a paper coffee cup—the way most New Yorkers take their coffee, to-go. *Photo by the author.*

Middle: In the opening decade of the 2000s, Ninth Street Espresso was notorious for being among the first coffee bars to offer triple ristretto shots: highly concentrated coffee made with more coffee grounds than a standard double espresso but with roughly the same total finished volume (two ounces). *Photo by the author.*

Bottom: Ninth Street Espresso's signature blend is called Alphabet City, after the very lower-east Manhattan neighborhood in which the first shop opened, on East Ninth Street between Avenues C and D. *Courtesy of Kenneth Nye.*

The coffee's really good.'" Unhappy in their day jobs, Bell and Timbrell daydreamed about opening a spot of their own, and within a few years, they were putting the polish on their first store, in Brooklyn's Greenpoint.

A historically Polish neighborhood that still boasts more kielbasa than kale salad, Greenpoint seemed like the ultimate long-shot location for a specialty coffee shop in 2005—especially on a corner that was still a solid eight-minute walk from the nearest subway. Not only that, but it was among the first multi-roaster cafés, as well, challenging the notion of regular coffee to a very regular Brooklyn clientele. Timbrell and Bell put their faith in the fact that New York City truly does love an underdog, and it paid off; a year later, the couple took another gamble and opened a second location in the Chelsea neighborhood of Manhattan—upping the ante by audaciously asking customers to wait while every coffee was brewed to order.

Every. Single. One.

Given that the average New Yorker starts to fidget if they have to wait at a "Don't walk" sign, this seemed like a risky venture. Something magical happened, however, and the café was soon standing-room-only popular. "We had $30 days," Bell told the *New York Times* in 2008. "But we stuck it out. We believed in what we were doing, that once people tasted the coffee, they'd realize what they were missing and they'd come back."[160]

The original location of Café Grumpy, in Greenpoint, Brooklyn. *Courtesy of Caroline Bell.*

Café Grumpy's Chelsea location, the company's second shop and the first location in New York City to feature Clover brewing technology: the Clovers were $11,000 machines that brewed coffee in practically no time at all. Grumpy's by-the-cup brewing was an instant sensation and turned the café into a destination for coffee geeks. *Courtesy of Brett Leveridge.*

Café Grumpy, like Joe and Ninth Street (which now has five café locations as well as a roasting facility in the Chelsea Market), has grown apace of the demand for great coffee, though it's done so somewhat quietly. (Literally, its owners are undoubtedly the softest-spoken of anyone mentioned in this book. They are also not native New Yorkers, which might explain the volume: Bell was born in Germany and raised in New Jersey and Timbrell is Australian.)[161] By focusing on highly seasonal, high-quality single-origin coffee with a slow-brew focus, Grumpy ushered in a philosophy of retailing that focused on bean and beverage, not brand. The bags aren't flashy, the shops aren't hyper-stylized and the baristas don't even actually tend to be all that grumpy (though we all have our moments), yet the company became the model to emulate among cafés that slowly transitioned to roasting their own beans in order to fully integrate quality, values and service. Grumpy's roasting program started in 2009; shortly thereafter, Joe and Ninth Street also began sourcing and roasting, rather than buying wholesale.

Café Grumpy's frowning bean logo is almost too cute to appear actually grumpy. *Photo by the author.*

"When we first started," Bell says, "we went out to Victrola Coffee [in Seattle] for training, and they were roasting coffee in the back room there. We thought, 'How great, to have this control.'"[162] For several years, Grumpy partnered with some of the country's best coffee purveyors, as Bell and Timbrell slowly developed their plan to begin roasting for themselves—in part to have more control over quality but also as a way of allowing employees to grow with the company and explore different areas of coffee professionalism without necessarily staying in a barista role. "Roasting opens that up for people. It makes it more fun, they can learn more," says Bell. "Sometimes I go in and I feel like it's not even my store, there are so many things going on. It's amazing to see people grow and develop."[163]

That goes for more than just the people working in the cafés, as well. Thanks in large part to these four icons of the specialty 2000s, New Yorkers all over town woke up and smelled the single-origin espresso. Within a few years, quality-obsessed bars were popping up throughout the boroughs, many run by transplants to the city and inspired by their home café customs from Scandinavia, Australia, Italy and Japan—a trend that continues as the caffeinated city stares down the barrel of another decade in the twenty-first century. Somehow, though newer-comers have certainly peppered the landscape, there remains something distinctly New York about Gimme!, Grumpy, Ninth Street and Joe. Perhaps it's simply their ability to morph and adapt with trends, and their constant pursuit of perfection—a restless inability to stay static for any amount of time.

"I think you have to keep trying really hard every day because, it is competitive. People are fickle, trends come and go—but if you remain true to what you believe in, like being transparent with what you're serving and how you approach people, if you're doing a good job and you're honest, you'll survive," Bell says. "People will want to come back even if they go somewhere else a few times, or for a long time. I think you always have to try. You can't ever be complacent."[164]

An espresso shot at Joe Coffee Company, one of the local shops to switch to "bottomless" portafilters, or espresso handles without spouts. *Photo by the author.*

Journalist, longtime New Yorker and coffee fanatic Oliver Strand agrees, dissecting how the cycle of shops and café innovations epitomizes the tension that drives Gotham's evolving culture: "There's always been this great appreciation for what's old, and this great outrage when what's old disappears. Every nine months it's like, 'Argh, this place is closing, it's family owned, it's been here since 1912 and that's horrible.' Then you realize that's just part of the cycle of life. New York is a very unusual place in that it is less of a physical city as it is as an organism, and stuff that was not that old becomes older on your watch. When things become old on your watch it's a little humbling, but it happens over and over again."[165]

The earliest colonial coffeehouses lost their patrons to the pubs and private clubs; Alice Foote MacDougall's empire lost its business to diners and the Depression; and counterculture cafés of the swingin' '60s gave way to juke joints and wine bars. Will this latest cadre of cafés be replaced by the next great thing, or is the city's current obsession with quality, freshness and fanaticism here to stay? Nye half-jokes about his longevity (and influence) on the scene: "Don't call me the 'elder statesman' of coffee; I'm not even fifty years old yet," he says with a raised eyebrow. "This is a young person's business. Everything changes so fast, and it's totally driven by youth now, the specialty movement is all about young people. It forces it to remain young."[166]

"I think [at first] there's a good one to five years of just having a nice time with the coffee and not thinking too hard about what's in the cup," Strand says, remembering the first few years of the caffeinated 2000s, when everyone was groping around in the proverbial dark roast, figuring out what they liked. "There are people who tell me, 'Oh, I really like Joe,' and then, 'Oh, I really like a shop with like a super light roast,' There's not a lot in common there, but to that person it's all in the same category. At some point, that person will or will not figure out that there's a difference. That, I think, is what this moment in New York coffee is: the proliferation and normalizing of what was exquisite and rarefied and unusual. At the beginning it was just good or bad."[167]

The coffee shop has obviously had a huge amount of sway on popular opinion and has unquestionably had a hand in driving New Yorkers' expectation of what good or bad coffee is, but how much has the reverse been true as well? While there's no accounting for taste, there is accounting for the way those tastes are shaped, and the preferences of the people are part of what has always fueled the ever-evolving coffee scene in Gotham. The future of the coffee shop is at the mercy of its customers, so we'll settle up with the barista and take a closer look at who's on the other side of the counter in the next chapter: the coffee-drinking New Yorker.

4

REGULAR

Coffee Drinking Habits of New Yorkers

The New Yorker identity is as complicated as the city itself: on the one hand, there's arguably no other place in the United States that so embodies the American melting pot; on the other, New York is so deeply *unlike* any other place in America that the former seems like a total contradiction. New Yorkers themselves are the same: the local population illustrates a very American cultural mishmash, yet the result is a unique amalgam that defines the singularity of "New Yorkness." Just as the history of coffee here almost *is* the history of New York, the drinking habits of its inhabitants speak to their constant evolution, the nervous and sometimes spastic energy that has built the place up (and, occasionally, torn it down).

When discussing coffee drinkers, there's naturally going to be some overlap with the other aspects of coffee mentioned in these pages so far—after all, to drink coffee requires the work of the coffee merchants, roasters and often cafés. Think of the city's caffeinated history as a kind of ecosystem, with the consumers ultimately pulling and being pulled along the chain of supply and demand. Whether New Yorkers drink too much coffee or not enough, the beverage itself is a part of the fabric of life and self here. Even David Letterman admits that "if it weren't for the coffee, I'd have no identifiable personality whatsoever"—and if his personality doesn't define New York, then what in the world does?[168]

As mentioned in the beginning of this story, even before New York was New York, it was New Amsterdam, a Dutch settlement started with the sole intent of making money. While English colonists carved out religious

and cultural enclave societies farther northeast, the Dutch founded New Amsterdam with more open-minded and open-market ideals. They viewed diversity as a trade strategy and included foreigners at the bargaining table because it meant greater financial opportunities.[169] As in Europe, coffee was part of that cultural and commercial landscape. Coffee was already a beloved part of Dutch life and commerce by the mid- to late 1600s, when ships carrying settlers started beaching on New World shores. The founding population planted roots and, in far southerly colonies in Central and South America, also planted the coffee trees themselves.

While English colonists hadn't had as long exposure to coffee in the old country, they quickly picked up on the custom after assuming control of what would become Manhattan in 1664; coffee was added to tea and ale as the beverages of choice. (Reliable potable water was hard to come by until the mid-nineteenth century, thanks to pollution and sea salt; the Croton Aqueduct, which helped make drinking water widely available to New Yorkers, wasn't finished until 1842.)[170] Coffee was very much a luxury item: expensive and exotic, available in certain establishments by certain segments of the population. For the most part, colonial caffeine was taken primarily at home, and while it was purchased, roasted and brewed by women within the household, it remained something of a male indulgence. Most coffeehouses barred women from entry, and coffee itself was seen as a catalyst for manly discussions on business and politics.[171] From the earliest days of American coffee drinking, this battle of the sexes was evident in female petitions to shut down coffeehouses and men's complaints about their wives' bitter brews; as late as the 1960s, ads depicting a husband's unalienable right to good coffee at the breakfast table still regularly appeared, while brewing guides dominated the ladies' pages of the daily newspapers.[172] (Even Mr. Coffee got into the gender wars, if by title alone.)

Coffee consumption grew steadily in popularity as commercial manufacturing improved and the city's commercial and residential landscape changed. After the Revolutionary War, industry and innovation swept Manhattan and downtown began to mature into a full-fledged force of finance. New York's population swelled as opportunities grew, fanning the flames of an entrepreneurialism that would eventually create a caffeinated boom, both directly and indirectly. Commercial roasting on a small scale began in the late 1700s, such as at one "coffee manufactory" at 4 Great Dock Street, where, "the proprietor announced that he had provided himself at considerable expense with the proper utensils to 'burn, grind and classify coffee on the European plan,'" selling his wares "in pots of various sizes

from one to twenty weight, well packed down, either for sale or family use so as to keep good for twelve months."[173] In 1833, New York's first large-scale commercial coffee roasting machine was imported from England, and by the middle of the 1840s, a wholesale roasted-coffee market was developing slowly but surely, making the beverage even more easily accessible and certainly more convenient—though not any easier to brew, which we'll get to shortly.[174]

Per person, consumption by New Yorkers was up to three pounds annually by 1830; this increased to more than five pounds by 1840 and eight pounds by 1850.[175] (Though it seems a pittance against today's standards, the relative expense and exclusivity of coffee at the time make these figures the modern-day equivalent of practically drowning in the stuff.) The growing demand for coffee led to the creation of new farms to contribute to global supplies, and British, Spanish, Portuguese, French and Dutch colonial governments planted as much coffee as the land would hold on vast swaths of Central and South America and the Pacific Islands, seeking to sell the crops to the wide-open U.S. market. By the middle of the nineteenth century, North Americans were drinking more coffee from their own hemisphere than had been dreamed possible only a generation prior, and the prolific yields and proximity of producing powerhouses like Brazil and Colombia allowed the price of coffee to become more democratic at exactly the same time that the middle class was gaining traction. Long factory hours and the tireless pace of city life made coffee a stimulating necessity to the average New York workingman; street vendors, all-night restaurants and food halls made it ubiquitous. Together, this supply and demand fueled the tremendous expansion that cemented NYC's position as the metropolitan nucleus of the East Coast, the seat of industry and shipping and the cosmopolitan center of the United States.

A coupon envelope printed by Arbuckle Brothers. This would be included in packages of Arbuckles' coffee as incentive for returning coupons toward premium rewards. *Author's collection.*

The last years of the Civil War period, 1864 and 1865, were incredibly significant for New York's coffee life. First, as we learned earlier, Jabez Burns unveiled his vastly improved coffee roaster, making it easier than ever for companies to sell roasted coffee at a retail and large-scale wholesale level. The following year, John Arbuckle (then still a Pittsburgher, though he would open his enormous Arbuckle's Coffee manufactory in Brooklyn in 1881) became the first roaster to sell his beans in individual packages, "like peanuts." These improvements arguably cleared the last remaining smoke from kitchens everywhere, as now households could acquire professionally roasted beans at low cost and high convenience.[176] Combined with the waves of Union soldiers returning from the Civil War with a taste for coffee, which had been included in military rations for the first time during that conflict, there was no turning back for New Yorkers, for whom caffeine had undeniably become a happy habit. The onset of the early temperance movement in the 1890s helped push the coffee-guzzling trend upward, as did the frenetic mood buzzing around the city before and during World War I, when coffee became a great (and cheap) comfort to civilians keeping the home fires burning. Where the entire United States imported just over 4 million pounds of green coffee in 1790, by 1910, nearly 734 million pounds came through New York and New Orleans alone.[177] A nickel bought a cup and some respite from the workday almost anywhere; even the poorest local toiler could afford that luxury. In the subsequent peacetime, New Yorkers turned to coffee when booze was taken away; Prohibition saw the typical American "drinking 100 more cups of coffee a year than he did in the old days; and a good part of the increase is attributed to newly formed habits of drinking coffee between meals, at soda fountains, in tea and coffee shops, at hotels, and even in the home."[178] By 1923, the *New York Times* was reporting that the city consumed 25 percent more coffee than the national average.[179] According to a hotel steward interviewed for the story,

> *More coffee? Sure! Why, out in other cities I could nearly always tell a New Yorker among the guests by the way he wanted his coffee. The New York business man wants it strong and he always did—even before prohibition. He drinks more of it. He takes a cup now and then to steady him. Strong and black. Almost anywhere else you put two and a half to three pounds of coffee in a five-gallon urn. If you are making demi-tasse, in New York you have to use at least four and usually five.*[180]

In fact, New Yorkers did tend to prefer a little burn in their mugs: "City" and "Full City" were the common terms for the roast level typical to Gotham's beans, indicating a slightly longer preparation in which "the bean is dark brown, shows no oil on the surface, and gives a deeper heartier cup."[181] Where drinkers in New England preferred a lighter, more cinnamon-color roast, citizens of the city that never sleeps long demanded something with enough *oomph* to match the energy of the place.

As the 1920s wore on and the United States slumped into financial crisis, the nation's coffee demand didn't dip. In fact, it increased during the depths of the Great Depression, and by 1932, American imports had jumped by 250 million pounds.[182] Even as the elaborate and expensive coffeehouses (like Alice Foote MacDougall's) shuttered, luncheonettes and diner counters were jammed with struggling locals who could at least scrape together two coins for a sandwich and a cup of something warm. "The American breakfast cup is a food-beverage because of the additions of milk or cream and sugar," wrote W.H. Ukers in his seminal *All about Coffee*, summing up in one line how coffee moved to the center of the table.[183] The outbreak of World War II closed Europe's markets to coffee imports, which drove prices down and consumption up in the frazzled States: "From 1939 to 1945 imports soared to 16.8 million bags, the highest annual average consumption for any seven-year period in United States coffee history previous to 1945," wrote Andrés Uribe C. "When the war ended coffee drinkers demanded even greater supplies. Imports during the period from 1946 to 1953 averaged 20.4 million bags yearly, culminating in 1949 with the record figure of 22,105,000 bags."[184]

The postwar era, however, was to see huge transitions in the city's drinking habits. Returning veterans found that the soluble "instant" coffee they had been given in their trench kits was good enough for civilian life; housewives wholeheartedly agreed, as it also helped around the kitchen. Young people discovered soda, a better way to perk up and easier-drinking than their parents' bitter brews. When frost in Brazil in the mid-1950s sent the cost of coffee skyrocketing, financial pressures forced many small and independent businesses to sell. This consolidation was the death knell for longtime regional brands that had come to embody the city's energy and personality. Others, like Chock Full o'Nuts, would eventually respond to the competition by begrudgingly introducing instant coffee to their offerings, damaging their regular coffee's margins.

To stay afloat throughout the 1950s and into the '60s, New York roasters began stretching their product by roasting low-quality beans to a lighter profile to reduce shrinkage (beans' weight loss as a result of the roasting

process). Consumers stretched their purchases by using less and less coffee in their recipes—a combination that led to bitter, watery swill.[185] All too quickly, this unpleasant but vaguely coffee-flavored drink became the norm, and coffee producers and roasters the world over tried virtually everything "in a tremendous campaign to educate the American housewife and restaurant man to go back to making coffee properly, that is, to get 40 cups to the pound instead of 65."[186]

There were bright spots and bold coffees to be found, however. The vast and diverse market potential of New York City meant that specialty stores for the truly coffee-obsessed could not only survive but thrive as gourmet oases amid a sea of bland brown water. A 1958 *New York Times* feature directs coffee crusaders to "old-fashioned" coffee stores still fresh roasting and custom blending for taste rather than straight economy. The Schweitzer Coffee Company on East Fifty-Ninth Street featured eight proprietary blends; Morris Schapira's Flav-R-Cup coffee company on West Tenth Street in the Village did a tidy mail-order business as well as local sales; the third-generation-run House of Yemen on Ninth Avenue in the Garment District kept things exotic with an Arabian-style coffee roasted to a "cinnamon" color, pulverized and "cooked with sugar in a *jezbeh*, a brass Turkish pot with a long handle."[187]

Though bean stores like these continued to quietly serve the most dedicated demitasse hunters—and eventually pass the torch to the new breed in the 1980s, like Oren Bloostein's Daily Roast—the huge commercial success of soft drinks and the mercenary marketing of the cola wars drove coffee into a near coma. The 1970s saw the per capita chugging of bottled energy and soft drinks more than double, and by the mid-1990s, over half of the beverages consumed in the United States were fizzy, contained high-fructose corn syrup and were (perhaps ironically) pumped full of caffeine sloughed off from the coffee-decaffeination process.[188] By 1988, only 50 percent of the adult population of the United States confessed to drinking coffee and, for the first time in decades, people were drinking fewer than two cups daily.[189]

Thankfully, an increasing number of those measly two cups a day were of an up-and-coming quality once referred to as *gourmet*, better known since the 1990s as *specialty*. "A Gourmet is a person, not a product category; a fellow who enjoys and is a good judge of fine food and drink," wrote Gillies Coffee president Donald Schoenholt in 1989, and as a founder of the Specialty Coffee Association of America, it's safe to say he should know. He continued:

Specialty is the correct term of identification for beans of top flight character. It denotes a special height of quality, a coffee with distinctive merit in

the bean, in the nose, and in the cup. Specialty coffee should be distinctly different from coffee sold as a commodity. It should be pure Arabica variety. It should be of the highest grades. A specialty may be a novelty as are flavored coffees and caffeine-added blends. All specialty beans should be produced with more than an alleged attention to production details.[190]

The customers who bought and consumed these more premium, more exclusive and more expensive coffees were once called "gourmet," or the more derisive "yuppies"; today, just try to find any mention that doesn't include the word *hipster*. Call them what you will, but they transformed New York City's coffee culture from one of fifty-cent paper cups of twice-brewed, long-stewed brown water to one of coffee as a culinary expression, with single-origin single-variety offerings and cafés with white subway-tile backsplashes, reclaimed wood and avocado toast.

"That there is a complex relationship between class and food consumption is often remarked, first in the obvious sense that particular groups occupy differential market situations in terms of their ability to purchase certain foods, and second in the uses various groups make of foods and food preferences in marking themselves as distinctive from or in some sense like other groups," wrote anthropologist William Roseberry in 1996. "In the case of specialty coffee, one of its interesting features is that it is *not*, or is not meant to be, a 'proletarian hunger killer.'"[191] In other words, specialty coffee is consumed for pleasure and status, rather than survival. (Let's face it, though. No matter what's in the cup, coffee has always and will always be at least somewhat a matter of survival for New Yorkers. "Caffeine's all I have left," a midtown businessman sipping an iced cappuccino at the Coffee Experience told the *New York Times* in 1993. "I went off booze four years ago. My last cigarette was New Year's Eve. It was that or lose my wife and kids.")[192]

There is more to New Yorkers' drinking habits than simple pain or pleasure, of course. The history of coffee drinking here is rooted both in New York's singularity as an American city and also the myriad individual cultures that have contributed to that alloy—so much so that Gotham's coffee transcends even dollars and cents. New Yorkers drink it whether they're flush or flat broke, as the drink itself has long been a means of preserving memory, sustaining camaraderie or expressing pride for heritage and custom.

The immigrant history of New York is fascinating on its own, and it is certainly one of the things that makes New York City so unique. While every place has been influenced by immigrants to some degree, this city

Perhaps nothing speaks to the Regular Joe habits of New Yorkers and New Jerseyites than the fact that Jim Kerr, a longtime DJ on the local classic rock station Q104.3, has had his own blend of coffee in the Quick Chek convenience stores. *Photo by the author.*

is more thoroughly of them, for them and by them than any other single U.S. metropolis. The tension that exists between assimilation and cultural preservation, specifically since a wave of work-seeking Europeans started arriving in the mid- to late nineteenth century, has undoubtedly colored much of what the world outside the boroughs thinks of as New York attitude and tastes. Gotham's coffee drinking naturally follows suit. While it's been one of many warm and fortifying beverages enjoyed here since colonial times, coffee's local culture has been largely influenced by immigrant arrivals—as will probably continue to be the case until the lights go out on Broadway.

The first group to have a major impact on the coffee-drinking habits of the city were the German immigrants who began coming over in the 1830s. These settlers had a rich and long culture of cafés in the old country, and their love of fine coffee (and *küchen*) followed them across the Atlantic. Known primarily for their predilection for lager beer, Germans had actually grown exceptionally fond of coffee as a catalyst for lively discussions about art and politics. Though early-modern women's groups were the first to popularize what were known as *Kaffeekränzchen* in Deutschland—gatherings "for coffee, cake and free conversation"—men often defended the tradition

(sometimes writing under female pen names), "in opposition to the elite-inspired intellectual and legal movement that ought to squelch the growth in coffee consumption."[193] The Germans arriving in the United States in the first half of the nineteenth century were marginally more financially solvent than subsequent immigrants to the United States, though they came abroad to escape growing financial unrest and political upheaval back home.[194] These mostly middle- and working-class families created an enclave in a pocket of the Lower East Side that became known as *Kleindeutschland*, where their foodways, language and customs were preserved. One tradition the new neighbors retained was coffee drinking—and plenty of it. Since the early nineteenth century, Germany has been a close rival with the United States for coffee imports, and the drink was taken during meals, during outings and get-togethers, in cafés and at the famous *kaffeeklatsch* that would become an enormous part of the German American lifestyle.[195]

Soon, Little Germany was lined with bakeries where it was customary for factory workers to stop for pastry and a coffee, Lutheran churches hosting coffee hours and restaurants where a meal was not considered complete without a cup, often sweetened and stirred with generous amounts of warmed milk. The neighborhood began to change in the early 1900s as Germans migrated uptown to the Upper East Side's Yorkville section and out to the other boroughs; even as they became more assimilated into the general population, however, the *kaffeeklatsch* remained as part of the New York culinary landscape, and the German habit of lingering over coffee and strudel became as American as apple pie.

The second influential group to bring their coffee connection during the great influx of immigrants to the city were the Italians, who began arriving in New York in the 1860s. Single men, primarily young laborers from the poorer southern cities and Sicily, ventured to the United States to escape the poverty that plagued their small rural villages and towns. Most came expecting to move west and work on the massive rail expansion undertaken after the Civil War, but many found countrymen and comfort in New York City; they settled in enclaves downtown and worked in factories and gardens, as servers in restaurants or as pushcart vendors selling peanuts. Italian peanut vendors actually triggered an incredible wave of chain migration. Entrepreneurial immigrants would send word back to family and village promising jobs for other Italians, who would then make the long trip overseas. The cart owners then became prosperous and opened cafés, restaurants, bakeries and importing houses dealing specialty products like olive oil, bringing a taste of home to the booming new Italian immigrant demographic.[196]

Among that enterprising group of ambitious young Italian businessmen was Patsy Albanese, who opened the Porto Rico Importing Company in 1907 at 195 Bleecker Street, a strip already lined with fellow newcomers from back home. It served the predominantly immigrant community within a few-block radius, selling "coffee roasted on the premises, dried mushrooms, fettuccini, Fernet Branca, tea, coffee, unroasted coffee, coffee makers, pasta makers—all kinds of tchotchke."[197] So says the current owner of Porto Rico, no stranger himself to all kinds of tchotchke: Peter Longo is the third generation of Italian American store owners in his family, having taken over the shop from his parents. His grandfather Frank had been the proprietor of a "sanitary bakery" at 201 Bleecker, the current site of Porto Rico. There, he baked crusty loaves for the local red-sauce joints that formed the backbone of the heavily Italian Greenwich Village.

"My grandparents on my father's side were really classic Sicilian," Longo says, his voice the playful sing-song that's classic to born-and-bred New Yorkers. "They were the kind of people who put tissue between their shirts in the drawers. My Aunt Millie and my grandmother—if I was dirty I would have to wash my hands and face, and they would sit you at the table with a big cloth napkin and they would feed you soft-boiled eggs. I mean, it was

Exterior of Porto Rico Importing Company on Bleecker Street in Greenwich Village. (Don't call it "Greenwich Village" if you want to sound like a local; just "the Village" will do.) *Courtesy of Peter Longo.*

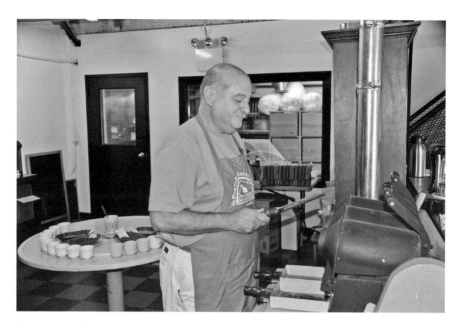

Peter Longo, owner of Porto Rico Importing Company, standing at a sample roaster. *Courtesy of Peter Longo.*

heaven. But they'd poke at you, and make you fix your eyebrows and wash your hands and face and all this stuff. It was very nice." He lingers on the word *nice*, smoothing the air with his hands.

Longo's father, Angelo, was a jobber during the Coffee District's heyday who "saw the handwriting on the wall" and bought Porto Rico from Albanese in 1958.[198] He hoped to expand the business into a full-fledged coffee, tea and spice importer and distributor. Angelo and his wife, Peter's mother Rose, ran the store as a family business, with the Longo clan living in the apartments above. "I get my personality from my father, and my sales skill and my drive from my mother," Peter says, sipping coffee from a paper cup in the back of the store at 201 Bleecker. "My mother was just a retailer like forget it. Behind the counter, she was really good. So she would do things like take orange peels and cinnamon sticks, break them up with a hammer, and put them in with the coffee. 'Try this,' she'd say. 'It's new!' My father would go ballistic, 'You're putting flavors in there, what are you talking about?!' Anyway, it took off."[199]

It sure did—and still going strong. Porto Rico on an average day is bustling, with Peter Angelo roasting coffees on the Probat in back of the store and staff scooping and weighing different coffees out of a dozen or

so barrels, grinding and custom-blending them to order. There are the more traditional offerings—Colombian beans and Kenya AA, black-brown espresso and oily French roast coffee—fancy stuff like Jamaican Blue Mountain and then the crème de la crème or, rather, the crème de menthe, tiramisu and Swiss chocolate almond flavored coffees, the latter with actual slivers of almonds mixed in, à la Rose Longo. The walls and shelves are lined with the knickknacks reminiscent of the old days, but with a modern (and mostly caffeinated) twist. There are the odd utensils—teabag squeezers, coffee scoops, tools for cleaning brewers—as well as filters, mugs, espresso machines and various obscure and even obsolete spare coffee-maker parts. There's a fine layer of Manhattan dust on many of the items. It takes a long time to create a museum-like atmosphere like this. "My growth has been slow, but our momentum is tremendous," Longo says.[200]

At Porto Rico Importing Company, coffee is still sold out of barrels and burlap sacks. Customers can create custom blends by request and buy as much coffee as they need at a time. *Photo by the author.*

While the early business was mostly geared toward Italian locals, eventually the clientele changed, as did the surrounding neighborhood. Porto Rico Importing, Longo says, "started out as a cultural reference, then it became artsy because people who are well-traveled came in and asked for things that they found in other places. They became sophisticated in their tastes." Longo saw the creeping in of Seattle-style coffee as an aid, not a threat to his business. "Starbucks comes along and generalizes the café society for a more suburban people, like you and me who are more nonethnic and don't have a cultural reference. They embrace coffee and it *becomes* their ethnicity, and it becomes their religion. They do just what nouvelle cuisine did for food, they do for coffee," he says with a playful smirk.

> *That's great, that's wonderful, because a new brain has taken an old thing and made it its own. For me, it popularized coffee to a whole different market who heretofore would really not shop in my store. They're walking down the street, and they see this crazy store, and they say, "Oh, let's take a chance, this is very exciting!" That's a hard way to gain customers, because it's close-up magic with each customer, which we do. And that's very important. But it goes back to being a lifestyle business—you're not gonna make a million dollars doing that. You make a good living, but it's a lifestyle business.*[201]

Italian coffee did, to a certain extent, become something of a lifestyle for New Yorkers, but it didn't happen overnight. The incredible poverty of the typical Italian immigrant (the average life savings of a 1901 arrival was less than $10) and his isolation from family and home customs drew him to inexpensive restaurants and coffee bars, where he found brotherhood with his fellow new arrivals.[202] Feared and openly derided by Americans for being ignorant and clannish, the Italians were unified by a strong sense of preservation—both of culture and of self—and their exotic foods featuring garlic and sundried tomatoes took nearly two generations to fully appeal to New Yorkers—and their wallets.[203]

During the 1930s and '40s, semi-adventurous city dwellers—including immigrants from other European cultures—started branching out from their own enclaves to explore other neighborhoods, discovering hidden gems in ethnic corners like Chinatown and the mix of Bohemian and Italian joints in the Village—like Clementine Paddleford's favorite, Caffè Reggio. A longtime haunt for the MacDougall boys who gathered there after work and "played pinochle and drank coffee until Dominic shouted, 'Out!'

An older shot of Porto Rico Importing Company—not much has changed. *Courtesy of Peter Longo.*

I'm shutting him up to go home,'" Reggio (founded in 1927) is one of two locations in Manhattan commonly cited as having imported the country's earliest espresso machines—a distinction the charmingly shabby West Village haunt shares with the white-tablecloth uptown Italian restaurant Barbetta.[204] (Opened in 1906, Barbetta installed its espresso machine in 1911.)[205] Reggio

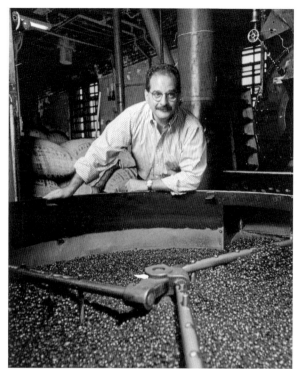

Left: Peter Longo of Porto Rico Importing Company in front of the cooling tray of a roasting machine at Harry H. Wolfe & Sons. *Courtesy of Peter Longo.*

Below: Caffè Reggio, a tiny Italian café in Greenwich Village since 1927, is purported to have one of the first espresso machines imported to the United States. Whether its cappuccino is original or not, it was one of Clementine Paddleford's go-to spots downtown. *Courtesy of Brett Leveridge.*

is still a popular spot for anyone seeking "old NYC," though like the rest of the area it's more undergrad than underground these days.

Through the late 1940s and 1950s, Bohemians and "slumming" uptowners alike became obsessed with cheap and heaping plates of pasta, but espresso was more of an acquired taste. Said New York restaurateur and cookbook author George Rector, "I have great respect for what comes out of the Italian kitchen in general, but their coffee ought never to come out at all—they should use it to remove the stains from copper kettles."[206] Slowly, more of what Peter Longo describes as the "Bohemian group" ventured into the Village for "a hot, jet-black coffee served in thimble-like portions," though it took a green mermaid and two more decades to make espresso accessible to a mass audience.[207] While the obsession might have been slow-growing at first, it makes perfect sense that once espresso caught on, it *really* caught on—after all, where else would the population so completely appreciate a hot wake-me-up that can be ordered, brewed and slugged in the course of a New York minute? It's no wonder Italian-inspired coffee bars have been the backbone of a half century's caffeine craze in the area.

However prominent the Italian influence has been, though, it's arguably the Greek immigrants, arriving en masse starting in the 1890s, who are the unsung heroes of Gotham's coffee culture. Without their mastery and command of the dining and hospitality industry through the twentieth century, coffee likely wouldn't flow as freely as it does in every borough, on every corner and in every cup.

Despite the deeply ingrained differences between the traditional American diet—increasingly processed, trans-fatty and red meat heavy, with plenty of added sugar and salt—and the diet most Mediterranean immigrants were used to—fresh fish and herbs, vegetables, olive oil, whole grains and nuts—Greek arrivals to the city saw an opportunity in the kitchens and lunch counters and almost immediately established a network of landlords, business owners and vendors who became the face of American cuisine in the city's eating places. Like the establishment of Italian peanut-vendor networks and the chain migration they inspired after the Civil War, arriving Greeks initially put their small savings into buying street carts and food wagons they would park in factory districts, peddling simple meals that could be eaten standing up by working men who needed cheap food on the double. Business was brisk, but laws targeting open-air food vendors were passed, making it difficult for the carts to continue. By the early 1900s, Greek vendors were investing in property instead, buying buildings and opening restaurants in the bottom floor, with the owner's family moving into the apartments above.

The commercial districts of lower and midtown Manhattan were soon lined with these casual-quick eating houses, and by the middle 1910s, there were about two hundred such establishments, many of which were open night and day and where "soup, roast lamb, potatoes, salad, Greek pudding and bread may be secured for thirty-five or forty cents."[208]

In her pivotal 1998 examination of immigrant foodways in America, *We Are What We Eat*, historian Donna R. Gabaccia examined the rapid domination of the urban diner landscape, musing over the fact that while Greek immigrants maintained strong national and cultural ties within their communities, their businesses were as American as grilled cheese. "In New York the only way to identify a Greek-owned diner or lunchstand might be the little blue paper cups decorated with the Parthenon and a frieze," she wrote of the culinary chameleonism. "Most of New York's 1,000 Greek-owned coffee shops and diners today still offer encyclopedia-sized menus and a gargantuan array of multi-ethnic desserts. But most of their offerings are not Greek food." It's lobster tails and pancakes, hamburgers and even matzoh-ball soup—assimilated cuisine for the needs of the neighbors and neighborhoods.[209]

And coffee. Lots and lots of it.

Simultaneous with the emergence of the short-order Greek luncheonette and diner came an enormous spike in mainstream American coffee drinking. The combination of temperance, recession and increased coffee imports turned the city into one big jittery mass of hardworking people seeking comfort in the bottom of a warm, cheap mug. The drink became a pick-me-up in more ways than one, and the Greek restaurant industry was perfectly poised to give the people what they wanted, including free refills.

Out in the depths of Flushing, Queens—basically as close to Flushing Bay as one can be without wading in it—remains one of the oldest and most exemplary reminders of the vast Greek influence on New York's coffee and culinary culture. Starting before sunrise, white trucks with the black Vassilaros & Sons logo pull in and out of a massive loading dock; they are filled with the day's orders—bottles of flavored syrup, spare machine parts, huge scallop-edged paper filters and boxes upon boxes of small foil packets, each containing the perfect amount of roasted, ground Vassilaros coffee. The trucks will bring these wares to countless locations in each borough—bodegas, diners, doughnut carts—and drive back to Flushing empty, ready to be filled with the next order.

Chances are very good that if you've lived in New York City for any length of time, you've tasted Vassilaros coffee—you've just probably never

Probably the most iconic caffeinated image in all New York, variations on the Greek-inspired Anthora cup can be found at almost any deli, bodega or doughnut cart in the city. *Photo by the author.*

known it. The company was founded by John A. Vassilaros, who arrived in New York at the turn of the twentieth century with no English, no money and no job. He met a fellow Greek immigrant who happened to own a coffee-roasting company and was recruited as a salesman.[210] His customers were other Greeks, restaurant owners and street vendors who brewed coffee constantly in their twenty-four-hour businesses. He learned the craft of roasting and struck out on his own in 1918 by opening a coffee business on Third Avenue in Manhattan, where he built on his established relationships within the Greek American food-service industry by offering loans of money and equipment, which could be settled up through brand loyalty to his coffee. In 1962, John's son Anthony took the helm to continue his father's business.

By 1962, the company was doing enough volume to warrant moving to the twenty-five-thousand-square-foot Queens plant where it remains today, and in 1964, Anthony's son, John's namesake grandson (Johnny), became the third generation to man the roasting machines; he served as company president until his death in 2015 and was well-liked and respected by the local roasting community.[211]

Throughout Vassilaros & Sons' history, as was the case with most of the Greek-operated food businesses, the customer base tended toward salt-of-the-earth types, not the diamond-and-pearl upper crust. "I sell coffee where coffee is important," John said in a 2013 video the company produced. "I don't make a coffee drink. I make a real cup of New York City coffee." Five million of them, actually—at least, that's what Vassilaros says is brewed every week in the New York metro area.[212]

The firm is still family owned and operated and is now in the hands of Stefanie Kasselakis Kyles, the late Johnny Vassilaros's niece and fourth-generation current company president. "I love to ride the trucks with the guys, making deliveries," she says. "They're up at four in the morning in the Bronx, in Queens—hard-working people. Some have been our customers for thirty, forty years." Kyles says that the Greek community has always "kind of stuck together," and most of the company's customers are referred by word of mouth (sometimes literally, as the coffee itself inspires plenty of business).[213] Even now, as the city's hospitality industry has ceased to be dominated by Greeks—"All these Greek businessmen who owned these restaurants started to realize the building was worth three times what they were making in the diner," Kyles says—the company endures on legacy, efficiency and ubiquity.[214]

"I think it's about the mass production. Recent Greek immigrants are really successful in that way, by mastering and presenting a really wide variety of what was still largely ethnic food [beforehand]." Gabaccia responds when asked what makes a particular food cease being ethnic and start being American—or even more specifically "classic New York." She says, "Ethnicity is regional, and it's immigrant-based. With mass-production, the consumer is looking at who's making the food and seeing that they don't have a particular cultural connection to it."[215] As coffee habits throughout New York's immigrant communities were stripped of their ethnic associations— such as the mainstreaming of German-inspired coffee and küchen cafés, the Bohemian-Italian crossover in Village espresso bars and the aforementioned dominance of Greeks diners—coffee itself simply became the blood in the city's veins. Today, the cross-cultural caffeination continues, as new waves of

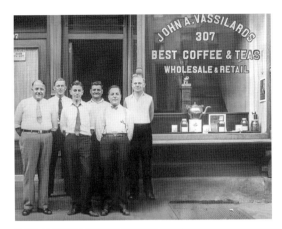

The coffee men of Vassilaros Coffee stand in front of the company's first storefront. *Courtesy of Vassilaros & Sons Coffee Company*.

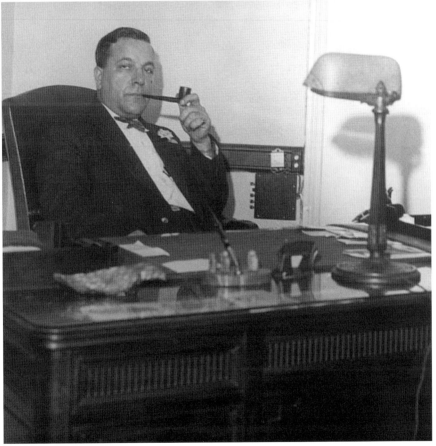

John A. Vassilaros Sr. *Courtesy of Vassilaros & Sons Coffee Company.*

Above: A convenience store in Midtown proudly displaying a Vassilaros & Sons Coffee sign. *Photo by the author*.

Left: John A. Vassilaros, who passed away in 2015. *Courtesy of Vassilaros & Sons Coffee Company*.

The Vassilaros booth at a coffee trade show. *Courtesy Vassilaros & Sons Coffee Company.*

immigrants bring their coffee traditions, many of which have been passed through various filters concurrent with globalization. Australian-style cafés with sit-down service, avocado toast and a peculiar latte-esque drink called a flat white have taken Manhattan and the hipper parts of Brooklyn by storm; while South Korean–owned coffee shops, including some prominent Seoul-based chains, are increasingly common in midtown and parts of Queens. Even "traditional" Italian-inspired stand-up espresso bars are filling the city's tiniest spaces, bringing the whole delicious mess around full circle.

"Uptown, downtown, all around Manhattan, coffee houses are the rage," Clementine Paddleford wrote in 1954—though she could have written it at any point during the past fifteen or twenty years. "Some are tiny, no more than a nookery, others are big as barns, but all are busy from 1 in the afternoon until 2 in the morning."[216] They were all full of New Yorkers, who are not known for spending terribly much time in their own kitchens (if they have one). The reason is partly practical—have you seen the size of these apartments?—and also highly defensible. Why cook when you live within a

stone's throw or a phone call from everything you could ever want to eat or drink, ready-made?

Coffee, however, has typically been the exception: even when water was scarcely potable; even when a household had no stove; even in the days of boardinghouses, and tenements built without kitchens at all—intrepid locals found ways to boil water, grind coffee, heck, even roast the stuff first. (A 1903 *New York Times* article recommended renting a gas stove for three dollars, as there were already "some 70,000 of these rented stoves doing duty on the Island of Manhattan," and specifically highlighted their utility in roasting the family's coffee.[217]) Nothing will stand in the average New Yorker's way when it comes to coffee, and the city's habits have changed not only with the trends and fashions, of course, but also with the technology, adopting fanciful and futile new ways to brew as well as adhering to time-tested and enduring methods, for better or worse.

The good thing about brewing coffee is that it is very easy to do; the bad thing is that it is very difficult to do *well*. (Just like roasting.) In modern history, a lot of time, money and frazzled nerves have gone toward scientifically brewing the perfect cup. In 1650s New Amsterdam, however, all that mattered was that the liquid was hot, fresh and reviving. The drink was primarily taken at home, roasted amateurishly and unevenly, ground with a hand mill or mortar and pestle, combined with boiling well water and "immediately removed off the fire and allowed to stand quietly" for ten minutes or so.[218] The coffee liquor was poured off once the grounds settled, which was sometimes aided by the addition of a whole egg, its crushed shell or a cup of cold water to clarify the brew. This method of infusion was modified by the Dutch and English from the active, rolling-boil brew preferred by Eastern traders who introduced the drink to them. While decoction produces an intensely thick drink, infusion results in a slightly clearer, sweeter coffee.[219] (I do love the image of the coffee "standing quietly," I'll admit.) Aside from very wealthy settlers who owned their own silver service or could afford imported wares, most New Amsterdammers and New Yorkers used cooking pots to prepare the day's brew, which meant it often tasted of whatever was on the previous day's menu.[220]

The convenience that buying roasted coffee afforded in the mid-1800s, in combination with the increased consumption and the virtual dependence that the newly industrializing city developed on caffeine, drove continued innovations in the market, leading to huge brewing advancements. Ceramic drip pots in the French style became fashionable: a two-piece device, the French dripper looked like the typical curved and contoured English-style

coffee server but with a perforated basket that sat on top. Ground coffee was placed in the basket, and boiling water was gradually poured through the bed. Once done, the basket with the spent grounds could be removed, leaving the liquor behind to be poured from the spouted vessel. In the early 1800s, a similar device was also invented in France and, mysteriously, given an Italian name: the Neapolitan flip pot, or *napoletana*, is like a French drip in reverse. Hot water is poured into the bottom of the brewer, and a perforated filter basket is screwed or secured on top. The device is then flipped to allow the water to pass through the grounds, and the thick coffee is poured from a long, straight spout into demitasse cups. With both drip and flip, the coffee was clear instead of silty, and less bitter and acrid to the American palate, which tended toward a preference for sweet, even somewhat bland, foods generally.

In 1895, author Joseph M. Walsh detailed several ways of preparing coffee for use—that is, not only for enjoyment but also medicinal purposes. For starters, his "ideal cup of coffee" need be "one part genuine Arabian Mocha and two parts finest Java," roasted separately and blended before brewing:

> *Fill an ordinary tea-cup two-thirds full of the coffee, with one raw egg and shell. Place the whole in a strainer or percolator and pour on one quart of briskly boiling water, then let stand for about ten minutes where it will keep hot without boiling, and serve with cream and sugar to suit, or, better still, with hot milk. But should a vessel without a strainer or percolator be used let the infusion boil up once, and pour in a cup of cold water, after which let it stand for at least five minutes to thoroughly settle, and you have a beverage brown, creamy, rich, fragrant, and delicious.*[221]

The term *percolator*, now a dirty word in coffee brewing, is actually typically misused, according to the coffee guru Ukers, and was something closer to what we call filter coffee. Percolation, he insists, means simply that the coffee is brewed by dripping through small perforations in a metal or china surface, as compared with the cloth or paper filter surface used in filtration methods. The dreaded "pumping percolator" invented in the 1810s, on the other hand, is instead "midway between decoction and infusion," as the coffee grounds are saturated again and again with already-coffee-infused liquor, boiling wildly in the vessel.[222]

The convenience of the pumping percolator—no belabored pouring, flipping or straining involved—ensured its popularity, despite its being "purely a perversion of taste" in Ukers's mind.[223] To Alice Foote MacDougall,

A portrait in her eponymous *Cook Book* shows Alice Foote MacDougall in a comfortable domestic setting. *From* Alice Foote MacDougall's Cook Book.

however, the pumping percolator was "the most satisfactory way and the one nearest fool-proof." She also admired it for its ability to blend nicely into the aesthetics of the breakfast table, "since tempers at 8 a. m. are not always what they should be."[224] (Though MacDougall also understood that the coffee would ultimately only ever be as good as the attention paid to it: "Coffee is a sensitive being. It has its whims and its fancies," she wrote, "and you, lady housewife, must guard the morals of your coffee as you do your children's, or your breakfast table tomorrow will be a place of wrath."[225])

When coffee prices began to rise after World War II, economic concerns drove more New Yorkers to brew at home: "Tempest in a coffee pot," steamed Clementine Paddleford. "Here we suggest making coffee's service a ritual for party occasions. If coffee is going to cost like an elixir for the gods, serve it in a manner to live up to the price."[226] Paddleford and other food writers on the ladies pages highlighted bean shops, as well as occasional specialty stores that sold exotic devices to re-create the hearty brews found at Italian and Mediterranean restaurants, but the pumping percolator was king. By 1956, the Pan-American Coffee Bureau reported that 64 percent of households were using the brewers—though the coffee itself was generally so poor quality at the time that it hardly mattered, and instant coffee drinking was skyrocketing.[227] David Schapira and his sons, Joel and Karl—who were all born into the coffee business via grandfather Morris's longstanding Greenwich Village bean store—lamented the state of coffee making in the city and beyond, since bad brewing practices inevitably would lead to bad buying ones as well, keeping quality down overall. "Americans could have adopted the method of filtration more than a century ago; ceramic and metal drip pots were available," they complained. "The Chemex coffee pot, invented over 25 years ago, could have caused widespread defection from the percolator camp, but no sweeping change in coffee-making practice occurred."[228]

A sweeping change did *finally* take place in 1972, however, when electric-drip Mr. Coffee machines were made available for home use. While commercial size and grade electric brewers had been in use for years, Mr. Coffee was the first automatic drip unit designed to fit snugly on a counter—even in a minuscule New York kitchen. In the company's first year, Americans bought 195,000 machines; by 1975, the figure was 6,200,000—more than thirty-one times the initial sales.[229] (While Mr. Coffee was invented by an Ohio entrepreneur, it had a special connection to the Bronx, which is what partially warrants its inclusion. Yankees great Joe DiMaggio was the company's longtime spokesman, promising that the machine's design "filters out oil, sediment

and bitterness," but "filters in great coffee flavor.") Though certainly more convenient than manual brewers, electric drip-pots were also imperfect machines: Difficult to clean—all that plastic—and inconsistent in heating and dispensing water, the quality of the coffee they produced was often no improvement over that made by the tedious methods they replaced. What they did accomplish, however, was bringing more coffee into the home, as the ease and efficiency of the automated process encouraged more households to add mugs of it to the breakfast, lunch and even dinner table now that it was truly as simple as flipping a switch.

Did this increase in home-brewing contribute to the meteoric rise of specialty coffee in the 1980s? It certainly marked a shift in the way New Yorkers appreciated not only *how* they were making coffee, but also *what* kind of coffee they were making. Passionate retailers like Donald Schoenholt, Peter Longo and the Schapiras found that a new generation—yuppies, hippies, foodies, call them whatever you will—were discovering the single-origin offerings and fresh-roasted beans that tasted, well, *special*, and a generation of coffee lovers both new and newly reawakened began looking to the past for inspiration on how to treat these radical coffees. Just as chefs all over the city are rediscovering ages-old techniques and calling them artisanal, the coffee culture in New York has likewise moved forward by, in some cases, taking a step back. While Starbucks certainly had a hand in democratizing a type of finer, more premium coffee beverage, New York consumers quickly began queueing up elsewhere as well, seeking out and supporting upstart coffee sellers whose focus was laser-pointed on the beans themselves. By-the-cup brewing at independent and locally owned shops like Café Grumpy, public cuppings hosted by coffee professionals and classes about home brewing and coffee buying offered by baristas and roasters all over town speak to Gotham's increased awareness and interest in buying better, brewing better, and drinking much, much better coffee.

"One of the stations of coffee is that large companies very rarely acknowledge that, 'Well, actually, this is a mediocre product, but we're optimizing our product while also getting you a good deal.' There's a certain amount of bullshit," says the caffeinated journalist Oliver Strand. "This new generation of coffee might not have 'discovered' anything, but they want to challenge all that, and actually say, 'This isn't amazing, and this isn't good.' There's an earnestness, and I think that's actually one of the great identities in this generation in coffee that might not be revolutionary in terms of the actual execution, but is revolutionary in terms of approach."[230]

Coffee drinking in New York has certainly gone through as many permutations as the city itself and will continue to evolve until Manhattan island sinks into the Hudson. New Yorkers will also always be opinionated about what they drink, though those preferences may change with trends—for better or worse. Hena Coffee's Scott Tauber sums it up perhaps more succinctly in his native tongue: "So it was good, it turned shitty, and now it's good again."[231]

Couldn't have said it better myself.

EPILOGUE

There is many a slip between the cup and the lip," the Schapiras wrote. "But if we find that much coffee falls short of the ideal, we also recognize coffee's potential to delight. The pleasure we get from good coffee urges us to seek the delights of great coffee."[232] The same can be said of New York itself. When things go right in this city, there's nothing more magical. The skyline is glisteningly perfect, there's art and music everywhere and strangers become friends. When things go wrong, however, the misery is deeply acute. You miss your train, get puddle-splashed by a bus and a pickpocket lifts your wallet.

If we wanted things to be easy, though, we'd live somewhere else—and certainly we'd drink something else. What we love, what we live for and what makes us real coffee-loving New Yorkers, however, is the thrill of the thing, the challenge that sweetens the reward.

Gotham's coffee chronicles tell their share of hard knocks, and along the way some of the city's best and brightest have gone down with the caffeinated ship. Risk takers like B.G. Arnold and Alice Foote MacDougall found success and failure in turn; the average lunch-goer sipped cups of questionable quality; and there were times when "It's Our Pleasure to Serve You" came punctuated with a flip of the bird. What gives New York its particular edge, however, is its capacity for reinvention at all costs—and that goes for the coffee, as well. MacDougall herself perhaps captured it best when she wrote, "I believe in burning one's bridges. I believe the only way to conquer is to walk where the battle rages most fiercely, and fight, fight, fight until you win."[233]

Epilogue

The fight does indeed rage on, in the cups and cabinets, on the counters and in the carafes of New York City. The locals may never agree on what's good or bad coffee, and there may be nothing as irregular as a regular cup, but that's the beauty of the place. The tension keeps it alive, and the caffeine, for better or worse, keeps it wide awake.

NOTES

Chapter 1

1. Jacob, *Coffee: Epic of a Commodity.*
2. Barker, "Green Coffee Grading"; Lepper, "Grading of Coffee."
3. Lepper, "Grading of Coffee."
4. Ibid.
5. Walsh, *Coffee: Its History, Classification and Description.*
6. Ukers, *All about Coffee* (2012).
7. Uribe, *Brown Gold: Amazing Story of Coffee.*
8. Jordan, "Women Merchants in Colonial New York."
9. Ukers, *All about Coffee* (1935).
10. Wakeman, *History and Reminiscences of Lower Wall Street and Vicinity.*
11. Ukers, *All about Coffee* (1935).
12. Wakeman, *History and Reminiscences of Lower Wall Street and Vicinity.*
13. Ibid.
14. Schapira, *Book of Coffee and Tea: Guide to the Appreciation of Fine Coffees, Teas, and Herbal Beverages*; Sterling Gordon, interview; "Good Coffee Men."
15. Wakeman, *History and Reminiscences.*
16. Ukers, *All about Coffee* (1922); Down Town Association website, www.thedta.com.
17. Thurber, *Coffee: From Plantation to Cup.*
18. Wakeman, *History and Reminiscences.*
19. Thurber, *Coffee.*
20. Schapira, *Book of Coffee and Tea.*

21. Newman, *Secret Financial Life of Food: From Commodities Markets to Supermarkets.*
22. Uribe, *Brown Gold.*
23. Huebner, "Coffee Market."
24. Wakeman, *History and Reminiscences.*
25. Ibid.
26. Colodney, "High Finance in Coffee."
27. Schapira, *Book of Coffee and Tea.*
28. Ukers, *All about Coffee* (1935).
29. Ibid.
30. *Annual Coffee Statistics: 1969.*
31. "Good Coffee Men."
32. "Good Coffee Men."
33. Ukers, *All about Coffee* (1935).
34. Ibid.
35. Uribe, *Brown Gold.*
36. Colodney, "High Finance in Coffee."
37. Ibid.
38. *Annual Coffee Statistics: 1969.*
39. *Tea & Coffee Trade Journal,* "New York Piers Chock Full of Coffee."
40. Roberts, *History of New York in 101 Objects.*
41. "Good Coffee Men."
42. Gordon, interview.
43. Donald Schoenholt, interview.

Chapter 2

44. Paddleford, "Tour of Coffee Plant Is Symphony of Aromas."
45. White Coffee Company website, www.whitecoffee.com; Coffee Holding Company website, www.coffeeholding.com; Barrie House Coffee website, www.barriehouse.com.
46. Scott Tauber, interview.
47. D.O. Haynes & Co., "New Coffee Firm Organized."
48. Donald Schoenholt, e-mail to author.
49. Tauber, interview.
50. Schneider, "F.Y.I."
51. Tauber, interview; Saul Zabar, interview.
52. Schoenholt, e-mail.

53. Steven Kobrick, interview.

54. Ibid.

55. Schoenholt, interview.

56. Ibid.

57. *New York Herald Tribune*, "Old Coffee Concern Buys Property for Expansion."

58. Ukers, *All about Coffee* (1935); *New York Herald Tribune*, "Old Coffee Concern Buys Property for Expansion."

59. *New York Herald Tribune*, "Old Coffee Concern Buys Property for Expansion."

60. Ukers, *All about Coffee* (1935).

61. *New York Herald Tribune*, "Old Coffee Concern Buys Property for Expansion."

62. Schoenholt, interview.

63. Ibid.

64. Ukers, *All about Coffee* (1935).

65. Schapira, *Book of Coffee and Tea.*

66. Ukers, *All about Coffee* (1935).

67. Ibid.

68. Schapira, *Book of Coffee and Tea.*

69. Karl Schmidt, interview.

70. *Simmons' Spice Mill*, advertisement.

71. Nagle, "Personality: Big Start Under the Stairs"; Saxon, "William Black, Founder and Head of Chock Full o'Nuts Corp., Dies."

72. Ickeringill, "Food: Erstwhile Nut Salesman Comes Full Circle"; Dennis Crawford, interview.

73. Auberach, "Chock Full o'Whatever It Takes."

74. Ibid.

75. Effrat, "Robinson Spurns 1957 Play Gambit."

76. Ickeringill, "Food."

77. Ibid.

78. Dougherty, "Advertising: A Man of Strong Convictions"

79. Saxon, "William Black."

80. Elliott, "Chock Full o'Nuts Draws on Its New York Ties to Give Its Image an Edge."

81. Schoenholt, e-mail.

82. Ukers, *All about Coffee* (1935).

83. Topik, "How Mrs. Olson Got Her Full-Bodied Coffee."

84. Oren Bloostein, interview.

85. Ibid.

86. Ibid.

87. Ibid.

88. Darleen Scherer, interview.

89. Scherer, interview.

90. *New Yorker*, February 5, 2007.

91. Scherer, interview.

92. Pulley Collective website, www.pulleycollective.com; Strang, "Roast of the Town."

93. Clayton, "Pulley Collective Hosts a Community of Small Batch Roasters in Red Hook."

94. Gabaccia, *We Are What We Eat*.

95. Kobrick, interview.

96. Ibid.

Chapter 3

97. Smith, *New York City*; Uribe, *Brown Gold*; Ukers, *All about Coffee* (1922).

98. Uribe, *Brown Gold*; Jackson, *Encyclopedia of New York City*.

99. Ukers, *All about Coffee* (1935); Jackson, *Encyclopedia of New York City*; Uribe, *Brown Gold*.

100. Ukers, *All about Coffee* (1935).

101. Ibid.

102. Jackson, *Encyclopedia of New York City*.

103. Lobel, "Out to Eat."

104. Ziegelman, *97 Orchard*.

105. Lobel, "Out to Eat."

106. Ernst, *Immigrant Life in New York City 1825–1863*.

107. Lobel, "Out to Eat."

108. Ibid.; Ziegelman, *97 Orchard*.

109. Lobel, "Out to Eat."

110. Foster, *New York in Slices*.

111. Ziegelman, *97 Orchard*.

112. Ukers, *All about Coffee* (1922).

113. Ukers, *All about Coffee* (1935).

114. *New York Times*, "Coffee Will Stay 5 Cents a Cup," August 16, 1946.

115. Roberts, *History of New York in 101 Objects*.

116. Smith, *New York City*.

117. MacDougall, *Autobiography of a Businesswoman.*
118. Ibid.
119. Ibid.
120. Ibid.
121. MacDougall, *Coffee and Waffles.*
122. MacDougall, *Autobiography of a Businesswoman.*
123. *New Yorker,* "Romance, Incorporated."
124. Ibid,
125. MacDougall, *Autobiography of a Businesswoman.*
126. *New York Times,* "MacDougall Shops in Receiver's Hands," May 25, 1932.
127. MacDougall, *Autobiography of a Businesswoman.*
128. *New York Times,* "MacDougall Shops in Receiver's Hands."
129. *New York Times,* "Alice F. M'Dougall Dies in Home at 77."
130. *New York Times,* "An Anti-Suffragist to Cast First Vote."
131. MacDougall, *Autobiography of a Businesswoman.*
132. Ukers, *All about Coffee* (1935).
133. Grimes, *Appetite City.*
134. Israels, "Her Passion Is Food."
135. Apple, "A Life in the Culinary Front Lines."
136. Paddleford, "Overlooked Italian Restaurant Uncovered by a Reader's Tip."
137. Paddleford, "New Guide Lists Specialties of 57 Restaurants"; Paddleford, "Dominic's Magnificent Italian Machine Serves Village Atmosphere and Coffee."
138. Paddleford, "Coffee with Sophistication."
139. Ibid.
140. Paddleford, "New Arrivals: Coffee Trees."
141. Mitgang, "New York's Caffe (Espresso) Society."
142. McGovern, "Coffee Mill."
143. Uribe, *Brown Gold.*
144. Schoenholt, "Gourmet."
145. Deutsch, "Commercial Property/Coffee Bars, Landlords Savor the Smell of Coffee Beans."
146. Kummer, "Coffee Talk: Suddenly."
147. Ibid.
148. King, "Company News."
149. Kummer, "Coffee Talk: Suddenly."
150. Brumback, "Cafe Grande."
151. Schoenholt, "Better Latte Than Never."

152. Jonathan Rubinstein, interview.

153. Ibid.

154. Ibid.

155. Ibid.

156. Ibid.

157. Kenneth Nye, interview.

158. Ibid.

159. Apologies to Gimme!, which is a very worthwhile company, but its Ithaca origins make it something of an outlier to the history presented in this book. The focus will be on the other three city-born businesses, but readers should visit the Gimme! Coffee locations in Brooklyn and Soho.

160. Botha, "Bean Town."

161. Caroline Bell, interview.

162. Ibid.

163. Ibid.

164. Ibid.

165. Oliver Strand, interview.

166. Nye, interview.

167. Strand, interview.

Chapter 4

168. Zehme, "Letterman Lets His Guard Down."

169. Smith, *New York City*.

170. Roberts, *History of New York in 101 Objects*.

171. Smith, *New York City*.

172. Quinn, *Scientific Marketing of Coffee*.

173. Ukers, *All about Coffee* (1935).

174. Pendergrast, *Uncommon Grounds*.

175. Smith, *New York City*.

176. Ukers, *All about Coffee* (1935).

177. Wakeman, *History and Reminiscences of Lower Wall Street and Vicinity*.

178. Ukers, *All about Coffee* (1935).

179. *New York Times*, "Coffee Drinking Grows."

180. Ibid.

181. Schapira, *Book of Coffee and Tea*.

182. Uribe, *Brown Gold*.

183. Ukers, *All about Coffee* (1935).

184. Uribe, *Brown Gold*.
185. Colodney, "High Finance in Coffee."
186. Ibid.
187. Ross, "Freshly Roasted Beans Are Key to Good Cup of Coffee."
188. Topik, "How Mrs. Olson Got Her Full-Bodied Coffee."
189. Roseberry, "Rise of Yuppie Coffee and the Reimagination of Class in the United States."
190. Schoenholt, "Gourmet."
191. Roseberry, "Rise of Yuppie Coffee and the Reimagination of Class in the United States."
192. Dullea, "What's the Buzz?"
193. Liberles, *Jews Welcome Coffee*.
194. Ernst, *Immigrant Life in New York City 1825–1863*.
195. Schapira, *Book of Coffee and Tea*.
196. Smith, *New York City*.
197. Longo, interview.
198. Witchel, "Grinding Beans Long Before the Baristas Came."
199. Longo, interview.
200. Ibid.
201. Ibid.
202. Ziegelman, *97 Orchard*.
203. Ibid.
204. Paddleford, "Saturday Out for a Boy and Girl."
205. Mitgang, "New York's Caffe (Espresso) Society."
206. Ibid.
207. Hollowell, "Rome Ignores 100-Degree Heat as Tourists Hunt for Secret."
208. Smith, *New York City*.
209. Gabaccia, *We Are What We Eat*.
210. Vassilaros & Sons Coffee website, www.vassilaroscoffee.com.
211. Stefanie Kasselakis Kyles, interview.
212. Vassilaros & Sons, video.
213. Kyles, interview.
214. Ibid.
215. Donna Gabaccia, interview.
216. Paddleford, "Coffee Houses Are Back in Fashion."
217. *New York Times*, "In the Shops."
218. Metropolitan Museum of Art website, www.metmuseum.org/toah/hd/coff/hd_coff.htm; Walsh, *Coffee*.

219. Walsh, *Coffee*.
220. Ibid.
221. Ibid.
222. Ukers, *All about Coffee* (1935).
223. Ibid.
224. MacDougall, *Coffee and Waffles*.
225. Ibid.
226. Paddleford, "Today's Living."
227. Shrum, "Selling Mr. Coffee."
228. Schapira, *Book of Coffee and Tea*.
229. Shrum, "Selling Mr. Coffee."
230. Strand, interview.
231. Tauber, interview.

Epilogue

232. Schapira, *Book of Coffee and Tea*.
233. MacDougall, *Autobiography of a Businesswoman*.

BIBLIOGRAPHY

Books and Articles

Apple, R.W., Jr. "A Life in the Culinary Front Lines." *New York Times*, November 30, 2005.

Auerbach, George. "Chock Full o' Whatever It Takes." *New York Times*, April 14, 1956.

Baldwin, Bertha K. "The Coffee Cup Seen from Another Angle: Three Blends of a Fresh Roast." *New York Tribune*, April 29, 1923.

Barker, Robert. "Green Coffee Grading." *Tea & Coffee Trade Journal* (November 20, 2003).

———. "Green Coffee Grading: Part II." *Tea & Coffee Trade Journal* (May–June 2004).

Bayer, Abba. "Green Coffee Association of New York City Celebrates 75 Years." *Tea & Coffee Trade Journal* (November 1998): 16.

Benjamin, Philip. "Then and Now." *New York Times*, April 15 1962.

Berry, Donna. "Beyond the Bean." *Dairy Foods* 109 (May 2008): 62.

Botha, Ted. "Bean Town." *New York Times*, October 24, 2008.

Boxman, Alyson R. "Oh Can Those Brooklyn Boys Roast Coffee…" *Tea & Coffee Trade Journal*, May 1, 1992.

Brown, Bob. "Vitamins in Italy." *New York Herald Tribune*, August 25, 1935.

Brumback, Nancy. "Cafe Grande." *Restaurant Business*, August 1, 2001, 39.

———. "Grounds for Expansion: Rising Gourmet Coffee Consumption Is Fueling an Explosion of Coffee Cafes." *Restaurant Business*, May 20, 1995, 112.

Brunn, E.M. "The New York Coffee and Sugar Exchange," *Annals of the American Academy of Political and Social Science* 155, no. 1 (May 1931): 110–18.

Carpenter, Murray. *Caffeinated: How Our Daily Habit Helps, Hurts, and Hooks Us.* New York: Penguin Group, 2015.

Claiborne, Craig. "Homemade Fare Distinguishes Food Shops in Greenwich Village." *New York Times*, February 2, 1961.

Clayton, Liz. "Pulley Collective Hosts a Community of Small Batch Roasters in Red Hook." *Edible Brooklyn* no. 32 (Winter 2014).

Colodney, Bernard. "High Finance in Coffee." *Analysts Journal* 15, no. 5 (November 1959): 69–78.

Conklin, William R. "Jackie Robinson Chock Full o'Poise as Executive." *New York Times*, March 9, 1958.

Cummings, Gil. "Hot Beverage Equipment." *Restaurant Business*, September 1, 1985, 200.

Deutsch, Claudia H. "Commercial Property/Coffee Bars, Landlords Savor the Smell of Coffee Beans." *New York Times*, November 6, 1994.

D.O. Haynes & Co. "New Coffee Firm Organized." *Soda Fountain: An Illustrated Monthly Publication for the Soda Fountain Trade* 21, no 1. (May 1922).

Dougherty, Philip H. "Advertising: A Man of Strong Convictions," *New York Times*, December 6, 1967.

Dullea, Georgia. "What's the Buzz? In New York, It's Coffee." *New York Times*, September 1, 1993.

Effrat, Louis. "Robinson Spurns 1957 Play Gambit." *New York Times*, January 8, 1957.

Elliott, Stuart. "Chock Full o'Nuts Draws on Its New York Ties to Give Its Image an Edge." *New York Times*, December 18, 2003.

Ernst, Robert. *Immigrant Life in New York City 1825–1863.* New York: Octagon Books, 1979.

Fader, Liz. "What's Happening in Flavored Coffees (Roaster, Retailer, Iced Profile)." *Tea & Coffee Trade Journal* (December 1991): 28.

Ferretti, Fred. "Consumer Saturday; Going Up: The Price of Coffee." *New York Times*, January 11, 1986.

Foster, George G. *New York in Slices.* New York: Garrett & Company, 1852.

Frush, Scott P. *Commodities Demystified.* New York: McGraw Hill, 2008.

Gabaccia, Donna R. *We Are What We Eat: Ethnic Food and the Making of Americans.* Cambridge, MA: Harvard University Press, 1998.

Grimes, William. *Appetite City: A Culinary History of New York.* New York: North Point Press, 2009.

Halfbringer, David M. "Whether Cup of Joe or Gourmet's Cafe, Coffee's Price Is Soaring." *New York Times*, May 13, 1997.

Hall, Guin. "19 Ways of Brewing Coffee Demonstrated at Altman's." *New York Herald Tribune*, May 11, 1954.

Hauck-Lawson, Annie, and Jonathan Deutsch, eds. *Gastropolis: Food and New York City*. New York: Columbia University Press, 2010.

Hewitt, Jean. "Exotic Beans from All Over." *New York Times*, January 14, 1975.

Hollowell, Frederick. "Rome Ignores 100-Degree Heat as Tourists Hunt for Secret." *New York Herald Tribune*, July 28, 1929.

Holsendoph, Ernest. "Rheingold's Rescuer." *New York Times*, March 24, 1974.

Huebner, G.G. "The Coffee Market." *Annals of the American Academy of Political and Social Science* 38, no 2. (September 1911): 292–302.

Ickeringill, Nan. "Food: Erstwhile Nut Salesman Comes Full Circle." *New York Times*, December 4, 1963.

Israels, Josef, II. "Her Passion Is Food." *Saturday Evening Post*, April 30, 1949.

Jackson, Kenneth T., ed. *The Encyclopedia of New York City*. 2nd ed. New Haven, CT: Yale University Press, 2010.

Jacob, H.E. *Coffee: The Epic of a Commodity*. Translated by Eden and Cedar Paul. New York: Skyhorse Publishing, 2015.

Johnson, Kirk. "Earning It; The Lure of the Coffee Bar, the Smell of the Grounds." *New York Times*, August 13, 1995.

Jordan, Jean P. "Women Merchants in Colonial New York." *New York History* 58, no. 4 (October 1977): 412–39.

Kamp, David. *The United States of Arugula: How We Became a Gourmet Nation*. New York: Broadway Books, 2006

King, Harriet. "Company News; Starbucks to Taste New York, at Last." *New York Times*, October 7, 1993.

Kummer, Corby. "Coffee Talk: Suddenly, New York Has Been Seattle-ized. The Ultimate Coffee Bar Guide." *New York Magazine*, May 23, 1994.

Leech, Margaret. "Romance, Incorporated." *New Yorker*, February 4, 1928.

Liberles, Robert. *Jews Welcome Coffee: Tradition and Innovation in Early Modern Germany*. Lebanon, NH: Brandeis University Press, 2012.

Lipstick. "When Nights Are Bold." *New Yorker*, August 8, 1925.

Lobel, Cindy R. "Out to Eat: The Emergence and Evolution of the Restaurant in Nineteenth-Century New York City." *Winterthur Portfolio* 44, no. 2, 3 (Summer–Autumn 2010): 193–220.

Lyman, Richard B. "Firm Moves Downtown to Expand." *New York Herald Tribune*, May 18, 1953.

MacDougall, Alice Foote. *Autobiography of a Businesswoman.* New York: Little, Brown and Company, 1928.

——. *Coffee and Waffles.* New York: Doubleday, Page & Company, 1926.

——. "The Woman in Business: Is She Unable to Do Justice to Her Family?" *New York Tribune*, October 22, 1913.

McCrary, Tex, and Jinx Falkenburg. "New York Close-Up." *New York Herald Tribune*, May 11, 1950.

McGovern, Isabel A. "The Coffee Mill, W. 56th St. Brings Kitchen to the Table." *New York Herald Tribune*, March 31, 1956.

Mitgang, Herbert. "New York's Caffe (Espresso) Society." *New York Times*, October 14, 1956.

Moody, Sue. "Coronation Breakfasts." *New York Herald Tribune*, May 9, 1937.

Nagle, James J. "Personality: Big Start Under the Stairs." *New York Times*, February 8, 1959.

Newman, Kara. *The Secret Financial Life of Food: From Commodities Markets to Supermarkets,* Kara Newman. Columbia University Press, 2012.

New Yorker. "Women Seem to Be Backing Down," June 4, 1932.

New York Herald Tribune. "Coffee with a Dash of Art: New Yorkers Are Discovering a New Type." August 31, 1952.

——. "Finds Girls Use Coffee Houses in Sobering Up: First Aid on Way Home," August 19, 1928.

——. "Old Coffee Concern Buys Property for Expansion," January 4, 1953.

——. "Robert Burns, 72, Dies; Was Head of Coffee Firm," November 10, 1929.

——. "W.G. Burns, Made Coffee Machinery," May 27, 1953.

——. "Woman Will Pay $137 Daily for Shop," February 11, 1927.

New York Times. "A Correction," February 21, 1979.

——. "Advertising: A Man of Strong Convictions," December 6, 1967.

——. "Alice F. M'Dougall Dies in Home at 77," February 11, 1945.

——. "American Coffee Drinker at the Mercy of Brazil," June 29, 1924.

——. "An Anti-Suffragist to Cast First Vote," October 26, 1924.

——. "Bowie Dash & Co. Suspend," December 11, 1880.

——. "Brief Reviews," March 4, 1928.

——. "Chock Full O'Nuts Recruits 3 Whites," August 8, 1963.

——. "Chock Full o'Nuts Shops Revert to Original No-Tipping Policy," July 6, 1974.

———. "Coffee Drinking Grows," October 11, 1920.

———. "Coffee Roasters Expand Downtown," January 3, 1953.

———. "Coffee Will Stay at 5 Cents a Cup," August 16, 1946.

———. "Full O'Nuts Gift Bigger Now," March 16, 1960.

———. "Greenwich Village: Glorying in Its Differentness; For 300 Years, a World Apart by Lawrence Block; Lawrence Block, the Author of the Matt Scudder and Bernie Rhodenbarr Mystery Series, Frequently Set Scenes of His Novels in Greenwich Village," November 20, 1988.

———. "In the Shops," June 3, 1903.

———. "MacDougall Shops in Receiver's Hands," May 25, 1932.

———. "New Coffee Pots Steaming with Design Ideas," October 19, 1956.

———. "Over 700 Had to Flee: Men and Women Employees of Arbuckle Brothers Were Menaced," February 22, 1895.

———. "Use of Having a Coffee Exchange," September 27, 1914.

New York Tribune. "City Intelligence," June 15, 1841.

———. "E.J. Gillies Falls Dead While Walking in Street: Succumbs to…" October 19, 1922.

Paddleford, Clementine. "Coffee Houses Are Back in Fashion." *New York Herald Tribune*, October 9, 1954.

———. "Coffee with Sophistication." *New York Herald Tribune*, January 16, 1958.

———. "Dominic's Magnificent Italian Machine Serves Village Atmosphere and Coffee." *New York Herald Tribune*, April 14, 1945.

———. "New Arrivals: Coffee Trees for Home, Tangy Cheese." *New York Herald Tribune*, March 7, 1961.

———. "New Guide Lists Specialties of 57 Restaurants." *New York Herald Tribune*, December 8, 1945.

———. "New Snap-on Collars Fasten Cellophane Bowl-Top Covers." *New York Herald Tribune*, July 30, 1947.

———. "Overlooked Italian Restaurant Uncovered by a Reader's Tip." *New York Herald Tribune*, March 13, 1948.

———. "Owner Finds Coffee Shop Changed Over Night: Caffè Reggio Transformed…" *New York Herald Tribune*, May 4, 1946.

———. "Recipes by the Way," February 21, 1956.

———. "A Renaissance Coffee Shop: The Peacock, in W. Fourth St., Is an Art." *New York Herald Tribune*, July 21, 1951.

———. "Saturday Out for a Boy and Girl: Dinner at Maria's Cin Cin, Coffee at Dominic's." *New York Herald Tribune*, November 11, 1950.

———. "Today's Living: Coffee Show-Offs Surprise at Dinner." *New York Herald Tribune*, November 18, 1949.

————. "Tour of Coffee Plant Is Symphony of Aromas." *New York Herald Tribune*, June 8, 1948.

Pendergrast, Mark. *Uncommon Grounds: The History of Coffee and How It Transformed Our World*. 2nd ed. n.p.: Basic Books, 2009.

Petran, Meredith. "What a Drip!" *Restaurant Business*, April 1, 1999.

Quinn, James P. "Scientific Marketing of Coffee." *Tea & Coffee Trade Journal*, 1960.

Roberts, Sam. *A History of New York in 101 Objects*. New York: Simon & Schuster, 2014.

Roseberry, William. "The Rise of Yuppie Coffee and the Reimagination of Class in the United States." *American Anthropologist* 98, no, 4 (December 1996): 762–75.

Rosenthal, Jacob. "Competitive Relations in the Coffee Industry." *Journal of Marketing* 1, no. 3 (January 1937): 191–97.

Rosenthal, J.R. "To Urge Cost Prices on Coffee Roasters." *New York Times*, December 20, 1931.

Ross, Hayburn. "Freshly Roasted Beans Are Key to Good Cup of Coffee." *New York Times*, December 4, 1958.

Saxon, Wolfgang. "William Black, Founder and Head of Chock Full o' Nuts Corp., Dies." *New York Times*, March 8, 1983.

Schapira, Joel, David Schapira and Karl Schapira. *Book of Coffee and Tea: A Guide to the Appreciation of Fine Coffees, Teas, and Herbal Beverages*. 2nd ed. New York: St. Martin's Press, 1982.

Schnapp, Jeffrey T. "The Romance of Caffeine and Aluminum." *Critical Inquiry* 28, no. 1 (Autumn 2001): 244–69.

Schneider, Daniel B. "F.Y.I.: The Beans of Brooklyn." *New York Times*, April 4, 1999.

Schoenholt, Donald N. "Better Latte than Never." *Tea & Coffee Trade Journal* (March 1996): 34.

————. "Gourmet: A Noun, An Adjective, An Accelerating Trend." *Tea & Coffee Trade Journal* (October 1989): 34.

————. "Rose Longo, Porto Rico Importing Co." *Tea & Coffee Trade Journal* (June 2013).

————. "Thinking of Roasting Your Own?" *Tea & Coffee Trade Journal* (May 1995): 52.

Shrum, Rebecca K. "Selling Mr. Coffee: Design, Gender, and the Branding of a Kitchen Appliance." *Winterthur Portfolio* 46, no. 4 (Winter 2012): 271–98.

Smith, Andrew F. *New York City: A Food Biography*. Lanham, MD: Rowman & Littlefield Publishers, 2013.

Strang, Oliver. "The Roast of the Town: A Collective Lets Small Coffee Shops Roast Their Own Beans." *New York Times*, July 30, 2013.

Strudivant, Shea. "Manhattan Special: Something Old that's Definitely New." *Tea & Coffee Trade Journal* (March 1991): 34.

"Superheated Steam for Roasting Coffee." *Science News-Letter* 48, no 20. (November 1945): 311.

Tasoulas, Mary Ann. "That Caffeine Fix: The Pulse-Quickening Growth Has Slowed, and the New Round of Expansion Has Been Largely Via Consolidation." *Restaurant Business*, September 1, 2000.

Tea & Coffee Trade Journal. "Gillies: Looking into the 90s and Back to Our Roots." March 1990, 17.

———. "New York Piers Chock Full of Coffee." May 1990, 30.

Thurber, Francis B. *Coffee: From Plantation to Cup.* New York: American Grocer Publishing Association, 1881.

Topik, Steven. "How Mrs. Olson Got Her Full-Bodied Coffee: The Industrialization of the Coffee Service Sector in the United States, 1760–1950." *Enterprise & Society* 2, no. 4 (December 2001).

Traub, James. "Far from the Madison Crowd." *New Yorker*, February 12, 1996.

Troyer, Ronald J., and Gerald E. Markle. "Coffee Drinking: An Emerging Social Problem?" *Social Problems* 31, no. 4 (April 1984): 403–16.

Tsounis, Catherine. "What Is the Future of Vassilaros Coffee?" GreekReporter.com, February 4, 2014.

Ukers, William H. *All about Coffee.* 1st ed. New York: Tea & Coffee Trade Journal Company, 1922.

———. *All about Coffee.* 2nd rev. ed. New York: Tea & Coffee Trade Journal Company, 1935.

———. *All about Coffee: A History of Coffee from the Classic Tribute to the World's Most Beloved Beverage.* Updated, abridged ed. Avon, MA: Adams Media, 2012.

———. "The Early Preparation of Coffee." *Wisconsin Magazine of History* 2, no. 3 (March 1919): 353–56.

Uribe C., Andrés. *Brown Gold: The Amazing Story of Coffee.* New York: Random House, 1954.

Wakeman, Abram. *History and Reminiscences of Lower Wall Street and Vicinity.* New York: Spice Mill Publishing Company, 1914.

Walsh, Joseph M. *Coffee: Its History, Classification and Description.* Philadelphia: Henry T. Coates & Company, 1895.

Warbuton, Clark. "Prohibition and Economic Welfare." *Annals of the American Academy of Political and Social Science* 163 (September 1932): 89–97.

Whitaker, Jan. "Quick Lunch." *Gastronomica* 4, no. 1 (Winter 2004): 69–73.

White, Gordon S., Jr. "Robinson, Incensed by Remarks of Bavasi, Is Adamant on Decision to Retire." *New York Times*, January 7, 1957.

Wiener, Sally Dixon. "News of Food: Pauses for Chats in Coffee Houses Help to Slow Down Busy New York Tempo." *New York Times*, February 27, 1954.

Williams, Lena. "How One New York Coffee Bar Came to Be." *New York Times*, January 19, 1994.

Witchel, Alex. "Grinding Beans Long before the Baristas Came: Porto Rico, a Venerable Old-Timer in Greenwich Village." *New York Times*, March 27, 2014.

Woodward, Helen. "Grab and Win." *New York Herald Tribune*, March 25, 1928.

Zehme, Bill. "Letterman Lets His Guard Down." *Esquire*, December 1994.

Ziegelman, Jane. *97 Orchard: An Edible History of Five Immigrant Families.* New York: HarperCollins, 2010.

Zirkle, Conway. "Review: The Romance of Coffee: An Outline History of Coffee and Coffee Drinking through a Thousand Years." *Isis* 40, no. 3 (August 2014): 291–92.

Websites

barriehouse.com
coffeeholding.com
pulleycollective.com
thedta.com
vassilaroscoffee.com
whitecoffee.com

Miscellaneous

Apuzzo, Joseph, Jr. "Big Opportunities for Green Coffee," excerpt from an address to the Green Coffee Association, August 1994. *Tea & Coffee Trade Journal* (March 1995).

Annual Coffee Statistics: 1969 (No. 33). Pan-American Coffee Bureau, 1970.

"Good Coffee Men." Video. Green Coffee Association of New York. 2014. Unreleased.

Haber, Barbara. "Cooking to Survive: The Careers of Alice Foote MacDougall and Cleora Butler." In *From Betty Crocker to Feminist Food Studies: Critical Perspectives on Women and Food*, edited by Arlene Voski Avakian and Barbara Haber, 120–142. Amherst: University of Massachusetts Press, 2005.

Lepper, Henry A. "The Grading of Coffee." Food Control Statement, No. 25. March 16, 1931. U.S. Food and Drug Administration.

U.S. Food and Drug Administration. "Beverages and Beverage Materials." Macroanalytical Procedures Manual: V-1. June 5, 2015.

U.S. Patent Application. October 29, 1935. J.L. KOPF ET AL 2,019,013. Joseph L. Kopf and John C. Kopi, assignors to Jabez Burns & Sons, New York. Application March 3, 1934. Serial No 713,794.

Interviews Conducted by the Author

Caroline Bell
Andrew Bloostein
Oren Bloostein
Dennis Crawford
Donna R. Gabaccia
Sterling Gordon
Steven Kobrick
Stefanie Kasselakis Kyles
Peter Longo
Caroline MacDougall
Kenneth Nye
Jonathan Rubinstein
Darleen Scherer
Karl Schmidt
Donald N. Schoenholt
Oliver Strand
Scott Tauber
Saul Zabar
Jane Ziegelman

Additional Correspondence

Stephen Bauer
Abba Bayer
Michael Del Gatto
Peter Giuliano
Caroline MacDougall
Scott Rao
Karl Schmidt
Donald N. Schoenholt

INDEX

ABOUT THE AUTHOR

This project is the intersection of everything Erin Meister loves in the world: coffee and New York City, obviously, but also history, reading and getting to know people with larger-than-life personalities. A coffee professional since 2000, Meister has worked as a barista, store manager, barista trainer and educator, wholesale account representative and salesperson. In her other life, she is also a professional journalist, writing about coffee (of course) as well as music, film, art, food, culture and travel. She loves a good interview and would almost always rather talk about anyone but herself.

After a dozen years in New York City and a lifetime in the tristate area, Meister now lives in Minneapolis, Minnesota. You can find her at www.justmeister.com, or by e-mail at meister@justmeister.com. (And feel free to call her just "Meister." Everyone does.)